American Drawings

in The Art Museum,
Princeton University

Barbara T. Ross

American Drawings

in The Art Museum,
Princeton University

130 SELECTED EXAMPLES

DISTRIBUTED BY PRINCETON UNIVERSITY PRESS

Dates of the exhibition: October 3–November 28, 1976

Cover illustration: Winslow Homer, *After the Storm*
(see no. 40)

Designed by Mahlon Lovett
Type set by Dix Typesetting Company, Inc.
Printed by Princeton University Press

Photography Credits:
Clem Fiori: nos. 9, 33, 39, 48, 55, 78, and 118.
Leonard Kane: nos. 21, 57–59, 83–91, and 127.
Sol Libsohn: nos. 4 and 10.
Elizabeth Menzies: no. 38.
Metropolitan Museum of Art: no. 16.
Taylor & Dull, Inc.: nos. 1–3, 5, 6, 8, 14, 17–20,
24–26, 29–32, 35, 42, 44, 46, 50, 52–54, 56, 60,
62–70, 72–76, 79–82, 92, 94–96, 98, 99, 101–103, 105,
106, 108–110, 114–117, 120–126, and 128.

Library of Congress Catalogue Card Number 76-27117
International Standard Book Number 0-691-03921-6
Distributed by Princeton University Press, Princeton,
New Jersey 08540

CONTENTS

FOREWORD

IT is altogether fitting that to commemorate the Bicentennial Princeton should choose to exhibit and publish selections from its holdings of American drawings, continuing efforts of the past several years to document and show a collection that is one of the strongest assets of the Museum. Catalogues in the past have dealt with selections from our French and Italian drawings and with individual artists, such as Guercino and Gaudier-Brzeska. The Laura P. Hall Memorial Collection and the Elsa Durand Mower Collection have had separate publications. Early in 1977, a two-volume catalogue of our Italian drawings will be published.

It is especially gratifying that in nearly every case our publications have been prepared by members of the staff or by faculty and graduate students in the Department of Art and Archaeology. In this instance, Barbara T. Ross, the Custodian of Prints and Drawings at the Museum for the past nine years, has devoted a considerable part of the last year to this project, thus enriching her own expertise as well as providing the Museum with documentation for its collection. It is hoped that this research for our American drawings will encourage interest in future projects, such as publication of drawings from the twentieth century as well as works by American illustrators, both areas of substantial holdings.

I wish to express my appreciation to all members of the faculty and staff who have assisted Mrs. Ross with this publication as well as with the accompanying exhibition to be held in the fall of 1976. The Museum is indebted to the National Endowment for the Arts for support of the project and to the Publication Fund of the Department of Art and Archaeology for assistance with this catalogue.

Peter C. Bunnell, Director, The Art Museum

INTRODUCTION

THE initial motivations for this endeavor were to revise the Museum's records for American drawings, to increase my knowledge of the collection, and to publish a representative selection of the Museum's holdings. In the process of my explorations, my affection for American art has increased measurably. I hope that I have conveyed some of my pleasure in these drawings along with the factual material concerning them.

The collection of American drawings at Princeton numbers over five hundred. It seemed that a division could be made between drawings done before World War I and those of the "modern" period. One hundred thirty drawings from the earlier group—largely nineteenth century—have been selected for study here. The few twentieth-century works that have been included are by artists who were in many respects in opposition to the new artistic trends so dramatically introduced into this country by the 1913 Armory Show. Drawings by graphic artists, illustrators, and naive artists have been excluded, as have dubious and inaccurately attributed works, even if they have been previously published. Only in the cases of John La Farge, Homer Dodge Martin, and Charles Herbert Moore has the number of drawings been limited. The result is perhaps an uneven selection, but one that fairly represents the Museum's collection of drawings produced by academic American artists before the second decade of this century.

Princeton's drawings collection, particularly the American section, can attribute much of its existence to the generosity of one man, Frank Jewett Mather, Jr. (1886–1953), Professor in the Department of Art and Archaeology, and Director of the Museum from 1922 to 1946. Three-quarters of the present selection was given by Professor Mather to the Museum during his lifetime. His enthusiasm as a collector and his eye for quality in individual draw-

ings and for their value as teaching examples have made this collection of American drawings one of the finest in the country. Professor Mather was author of important monographs on Homer Dodge Martin and Charles Herbert Moore, and he contributed to scholarship on Ernest Haskell, John La Farge, Winslow Homer, and others.

Another significant name in the history of the collection is that of Clifton R. Hall, Professor in the Department of History, who in 1946 bequeathed his own prints and drawings and a fund to purchase additional acquisitions in memory of his mother, Laura P. Hall. To this day most of the prints and drawings not acquired by gift have been purchased through this fund. A few select American drawings are included in a large and valuable collection of drawings bequeathed to the Museum in 1938 by Dan Fellows Platt, Class of 1895. Mrs. Platt generously waived her rights to life tenure of her husband's collection, and the drawings came to the Museum in 1944. Other important donors of American drawings have been Mr. and Mrs. Stuart P. Feld and Alastair B. Martin.

This compilation was conceived of more as an annotated and illustrated checklist than as a comprehensive catalogue. The reader will have to go to other sources for details of each artist's life. Only information relevant to the drawings at hand has been included. The length of the entries varies considerably. This is because of the diverse nature of the material and in no way reflects the amount of interest or effort on the part of this researcher. In fact, in many instances it was those drawings about which the least has been said that were labored over the longest.

In the catalogue entries themselves, only relevant inscriptions have been noted, to the exclusion of dealers' numbers, framers' directions, and other modern notations. The inscriptions are in the me-

dium of the drawing unless otherwise stated. The original intention to describe condition was abandoned when the manuscript began to take on the character of a forensic scientist's report. Provenance is included only when available; Frank Jewett Mather, Jr., was a frustratingly poor record-keeper, and it seemed more important to investigate the art-historical background of each drawing than its provenance. Sources on each artist have been cited only if they refer to the specific drawing discussed or contribute unique information. Many drawings in the collection were included in an exhibition organized by Professor Donald D. Egbert and held in McCormick Hall in 1943 (Princeton University, Department of Art and Archaeology and the Program of Study in American Civilization, 10 May–1 June 1943, "An Exhibition of Drawings by American Artists 18th–20th Centuries," *Bulletin of the Department of Art and Archaeology,* May 1943). References to this exhibition are abbreviated in the catalogue entries to read, Princeton 1943. Sources for reproductions of related paintings have not been given unless the paintings are obscure, and their owners are cited only when institutional or verified as current.

The obvious disadvantage of the alphabetical listing employed here is that it ignores historical context. Several of these artists, for example, had Albany origins in common, or were pupils of Thomas Couture or Jean Léon Gérôme. Others were fellow members of the Century Association or various artists' societies. Some were associated with the Düsseldorf school, the Hudson River school, or an American genre tradition. There are examples from America's earliest artists—West, Copley, and Sully—as well as latter-day academic painters like Paxton and the Hales. Perhaps some of these relationships will be studied in future publications.

I wish to thank particularly Lloyd Goodrich, who, through information he has supplied to the Museum in the past, has contributed much to the Eakins, Homer, and Ryder entries. Henry La Farge, the artist's grandson, was most kind in answering my many questions on his two visits to the Museum to study John La Farge drawings preparatory to his catalogue raisonné. Helmut von Erffa has made important contributions to the Benjamin West entries. The curators and staffs of the institutions I visited in the course of my researches were, without exception, extremely kind and helpful. These include the Archives of American Art in New York, the Art Institute of Chicago, the Brooklyn Museum, the Frick Art Reference Library, the Metropolitan Museum of Art, the New York Public Library, and the Pennsylvania Historical Society. Lawrence E. Spellman, Curator of Maps, Princeton University Library, has assisted me greatly in verifying geographical names. Those who have contributed specific information on individual artists are acknowledged in the relevant entries; I thank them all, most heartily, here and now. Finally, I thank my husband who read and commented on this manuscript, and endured weeks of evenings of hearing the typewriter, and his incomparable secretary, Constance Morey, who typed the manuscript. I thank, too, the staff of the The Art Museum, particularly Frances F. Jones, who patiently answered my many questions; Robert Lafond, who obtained all the photographs; and Virginia Wageman, whose work as editor, as I write this, is only now beginning.

American Drawings

130 SELECTED EXAMPLES

GEORGE HENRY BOUGHTON

near Norwich, England 1833–1905 London

1 *Landscape, Housatonic*

Pencil on greenish gray paper. 0.248 x 0.185 m.
Inscriptions: lower right by the artist, *Housato-nic— / July 17th 57;* verso, by the donor, *G. H. Boughton / from a scrap*[?] */ book / at Ho*[l] *man's*[?].
Gift of Frank Jewett Mather, Jr. (43-221)

Boughton spent most of his first twenty-two years in the Albany, New York, area. He visited England in 1856 to study; it was between this short trip and 1860, when he moved to Europe permanently, that this sketch was executed.

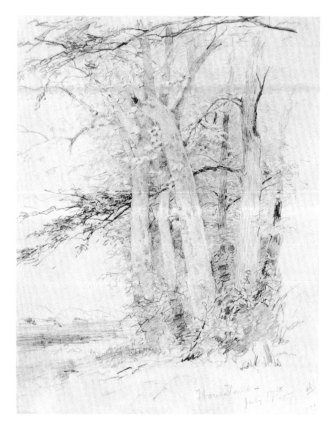

2 *Pine Tree Branch*

Soft pencil on blue paper. 0.238 x 0.355 m.
Inscriptions: upper right by the artist, various color
 notes; on old mat by the donor, *G. H. Bough-
 ton / from an album Holman's Boston*[?].
Gift of Frank Jewett Mather, Jr. (43-71)

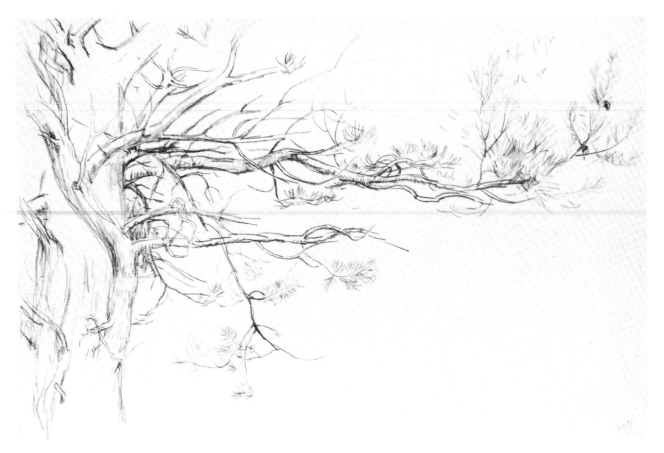

GEORGE LORING BROWN

Boston 1814–1889 Malden, Mass.

3 *Man Reclining under a Tree*

Pencil and white gouache(?) on thin, brown-washed
paper; touches of red watercolor on man's belt.
0.39 x 0.277 m.
Inscription: lower center in pencil by the artist, *G.
L Brown / Albano 1852.*

Gift of Frank Jewett Mather, Jr. (49-151)

Brown executed this drawing during an Italian
sojourn, between 1839 and 1859. Brown often in-
corporated scenes such as this in the foregrounds of
his landscape paintings.

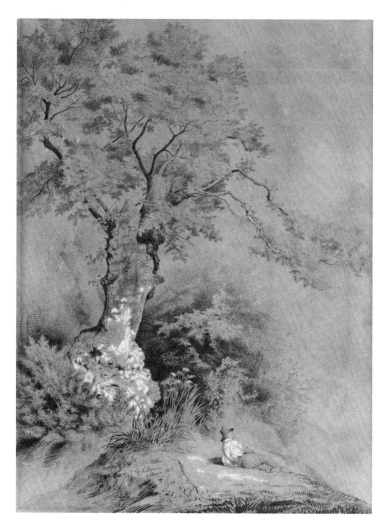

MARY CASSATT

Allegheny City, Pa. 1845–1926 Mesnil-Théribus, France

4 *Young Woman in a Black and Green Bonnet, Looking Down*

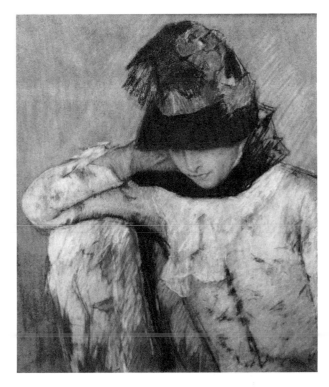

Pastels. 0.65 x 0.52 m.

Inscription: lower right by the artist, *Mary Cassatt.*

Provenance: artist's bequest to her companion, Mathilde Vallet, 1927; Mathilde X [i.e., Vallet] sale, Paris, 1927, no. 61; Chester Dale; Parke-Bernet, New York; Mrs. Potter Palmer, Chicago; Parke-Bernet, New York, P. Palmer and others sale, 16 March 1944, no. 62; purchased by the donor.

Exhibition: Paris, A.-M. Reitlinger, 1927.

Bibliography: Adelyn Dohme Breeskin, *Mary Cassatt: A Catalogue Raisonné of the Oils, Pastels, Watercolors, and Drawings,* Washington, D.C., Smithsonian Institution Press, 1970, no. 173 (illus.).

Gift of Mrs. Sally Sample Ely (53-119)

Also known as *Femme au chapeau* and *Jeune femme accoudée,* this drawing has been dated circa 1890 by Breeskin; the above provenance and exhibition information are hers. The 1944 Parke-Bernet catalogue indicates that the work was then the property of a ''New York Private Collector''; could the Palmer provenance be mistaken? Two other Cassatt pastels (Breeskin 172 and 174) appear to picture the same model wearing the same clothing.

Not in exhibition.

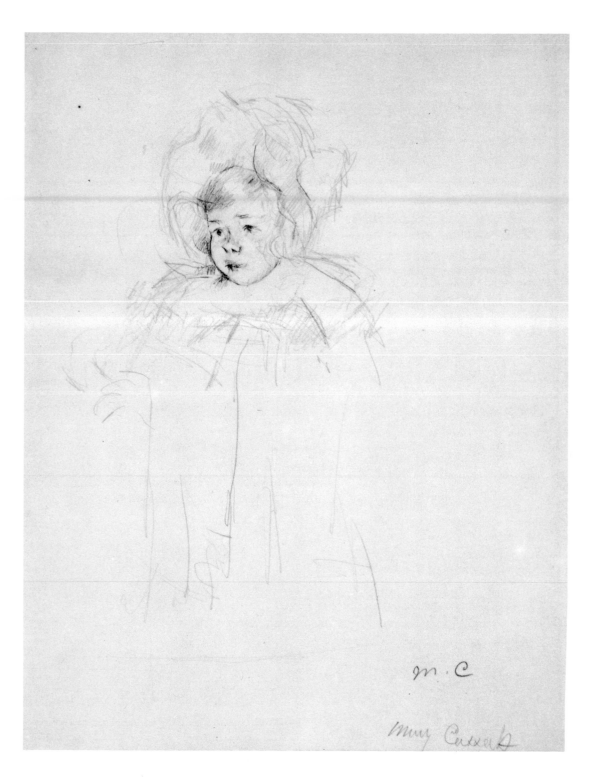

m. c

Mary Cassatt

5 *Little Girl in a Fluffy Bonnet*

Pencil. 0.325 x 0.25 m.

Inscriptions: lower right by the artist, *M. C;* below this in a harder pencil, *Mary Cassatt.*

Provenance: H. V. Allison, New York (label on back of former frame).

Bibliography: *The Laura P. Hall Memorial Collection of Prints and Drawings,* Princeton, Department of Art and Archaeology, Princeton University, 1947, no. 19 (listed).

Laura P. Hall Memorial Collection, bequeathed by Prof. Clifton R. Hall (46-164)

This sketch has also been called *Fillette au chapeau.* It is not in Breeskin [correspondence between the author and Mrs. Breeskin, 1975, indicates that this was probably an oversight rather than a deliberate omission]. The highlighting on the child's hair and the hairstyle are very like Breeskin 425 (*Portrait of Margot in a Large Red Bonnet*); but the facial features and the age of the child are closer to Breeskin 867 (*Louise in a Fluffy Bonnet and Long Coat*). The date of Princeton's drawing is undoubtedly the same as that of the two similar works, circa 1902. Margot and Louise were two of several unrelated young models who posed for the artist in dress-up attire.

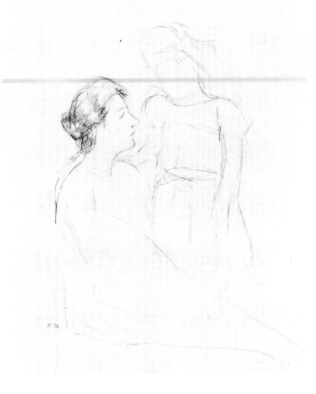

6 *Simone in a Big Hat beside Her Mother*

Pencil. 0.24 x 0.181 m.

Provenance: artist's bequest to her companion, Mathilde Vallet, 1927; Mathilde X [i.e., Vallet] sale, Paris, 1931(?), no. 32; William Michel; purchased by Dan Fellows Platt, 1931 (pencil note on verso).

Bibliography: Breeskin, *Mary Cassatt,* no. 909 (illus.).

Dan Fellows Platt Collection (48-8)

This drawing, like the preceding one (no. 5), was made during the last decade of the artist's career, before blindness forced her to retire. Breeskin sees a relation between it and the pastel *Simone Wearing a Big Hat Outlined in Black Ribbon,* circa 1904 (Breeskin 450), in which the young girl alone is shown; she is sitting with her hands in her lap, she has a smile on her face, and her dress has no sash or yoke.

THOMAS COLE

Bolton-le-Moor, England 1801–1848 Catskill, N.Y.

7 Tree and Rock

Pen and brown ink, pencil. 0.225 x 0.34 m.
Inscription: lower right by the artist, *May 25th 1823*.
Provenance: Mrs. Florence Cole Vincent (the artist's granddaughter); purchased by the donor at Cole's Catskill studio.
Exhibition: Princeton 1943, no. 7.
Bibliography: Louis Hawes, "A Sketchbook by Thomas Cole," *Record of The Art Museum, Princeton University,* 15, no. 1, 1956, p. 2.
Gift of Frank Jewett Mather, Jr. (40-84)

This rare drawing, which dates from the time that Cole lived in Pittsburgh, between spring 1823 and November of that year, demonstrates the artist's capacity at an early age for close observations of nature.

8 View of the Cattskill Mountain House

Verso: *Mountain Landscape with Lake*

Pen and black ink over pencil; rough pencil sketches at left side and top, perhaps by another

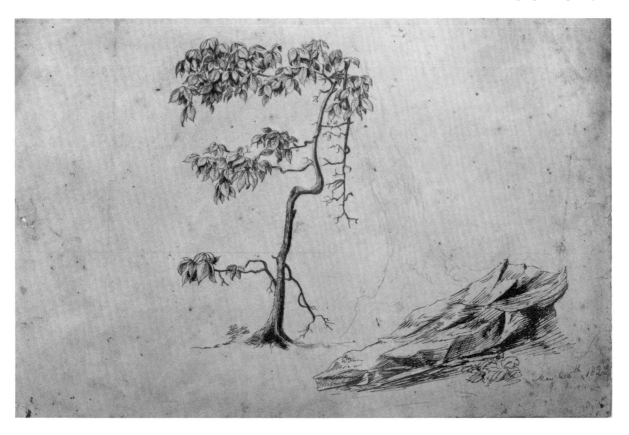

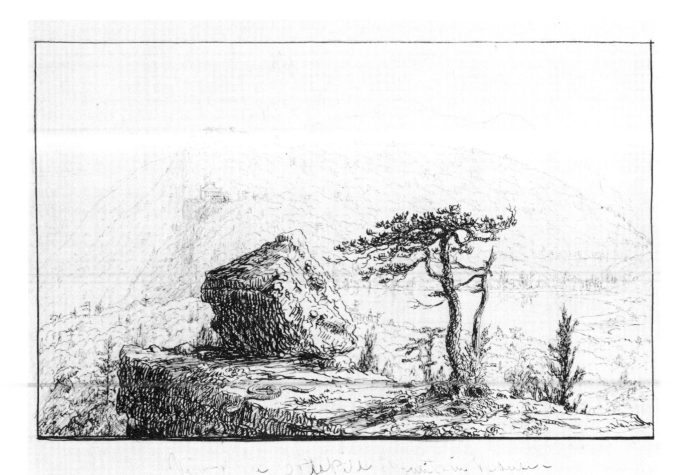

hand; even rougher, childlike additions in the lake at the right have been partially erased; on a sketchbook leaf with binding fold and thread holes at top. Verso: pencil. 0.237 x 0.392 m.

Inscriptions: lower margin by the artist, title as given; verso, miscellaneous descriptive notes, *Rocky knoll with green small trees on it / ¾ mile / The lake not quite wide enough / woods / bushy / Birch Tree brown / scattered woods / Rydal / [. . .].*

Provenance: Mrs. Florence Cole Vincent (the artist's granddaughter); purchased by the donor at Cole's Catskill studio.

Exhibitions: Princeton 1943, no. 6; *The Conservationist* (New York State Department of Environmental Conservation), 17, no. 5, April-May 1963, illus. opp. p. 5; Hartford, Wadsworth Atheneum, and New York, Whitney Museum of American Art, 1948–1949, *Thomas Cole 1801–1848: One Hundred Years Later,* no. 94; Brooklyn, N.Y., Brooklyn Museum, 25 November 1969–22 February 1970, *Drawings of the Hudson River*

School 1825–1875 (by Jo Miller), no. 29 (illus.).
Bibliography: Hawes, "A Sketchbook by Thomas Cole," cover (illus.) and pp. 21–22.
Gift of Frank Jewett Mather, Jr. (40-85)

This drawing is closely related to an oil painting of 1843–44 in the collection of Mrs. Calvin Stillman, New York. The rock and trees in the foreground have been changed in the painting and the snake has been omitted. Two other slightly different paintings by Cole and an engraving after Cole of the Catskill Mountain House are known. It has been suggested (Wadsworth Atheneum / Whitney Museum catalogue) that this is a record drawing; however, the facts—it does not correspond in many details to a known painting; it is on a sketchbook leaf with a sketch from nature on the verso; and similar pen and ink drawings exist that are preparatory to paintings—do not support this idea. It is more likely that this drawing was finished in the studio after a sketch executed from nature (perhaps the one in the Museum's Cole sketchbook, fol. 16v; see Appendix) and that Cole decided that the foreground was too distracting for inclusion in a painting. It is not inconceivable that those rough pencil additions which remain unerased are by the artist (cf. his sketchbook, fols. 18r and 20v). The sketch on the verso is perhaps a scene near the Catskill Mountain House. The same view was used in the painting *Approaching Storm* (Kennedy Galleries, New York, *An Exhibition of Paintings by Thomas Cole*, 1964, no. 9).

9 View in Somes' Sound, Mt. Desert

Verso: *Mill Pier*

Pencil, white highlights, on blue paper with residue of brown material on left edge as if torn from a pad. Verso: pencil. 0.25 x 0.358 m.
Inscriptions: by the artist, title as given / *Big Day*[?] *Mt.* / *reddish ground* / *wooded generally* / *Mill* / *see other side* / [. . .]; verso, *Shingled* / *door* / [. . .].
Provenance: Mrs. Florence Cole Vincent (the artist's granddaughter); purchased by the donor at Cole's Catskill studio.
Exhibition: Waterville, Maine, Colby College Art Museum, Brunswick, Maine, Bowdoin College Museum of Art, and Orono, Maine, University of Maine, Carnegie Gallery, 1970, *Landscape in Maine 1820–1970: A Sesquicentennial Exhibition*, pp. 14–15 (illus.) (misspelled Soames).
Gift of Frank Jewett Mather, Jr. (40-80)

10 Mountain Landscape, Probably Mount Desert, with Man Reading

Verso: *Detail of the Rocks and Trees at Right*

Pencil, white highlights, on blue paper. 0.25 x 0.358 m.
Provenance: Mrs. Florence Cole Vincent (the artist's granddaughter); purchased by the donor at Cole's Catskill studio.
Gift of Frank Jewett Mather, Jr. (40-81)

The two drawings above are in the same media, on the same kind of paper, and were made during the artist's trip to Mount Desert Island in August and September of 1844. The man reading in the center could well be Henry C. Pratt, who accompanied Cole on his trip (see Appendix, Cole sketchbook, fol. 8v).

11

11 *Raquette River, Outlet of Incapoco*

Verso: *Details of Center Rock and Large Tree at Right*

Pencil, white highlights, on gray paper. 0.247 x 0.356 m.

Inscription: upper right by the artist, *Racket River / Outlet of Incapaco.*

Provenance: Mrs. Florence Cole Vincent (the artist's granddaughter); purchased by the donor at Cole's Catskill studio.

Gift of Frank Jewett Mather, Jr. (40-82)

12 *Long Lake, Owls Head Mountain*

Pencil, white highlights, on gray paper. 0.247 x 0.356 m.

Inscriptions: lower left by the artist, *Sepr 16 1846 / Long Lake / Mt*[?] *head*[?]; upper right, *The shadows of the woods now*[?] *intensely dark dark*[?] *green / shadows*[crossed out] *lights / Mountain 2 miles off.*

Provenance: Mrs. Florence Cole Vincent (the artist's granddaughter); purchased by the donor at Cole's Catskill studio.

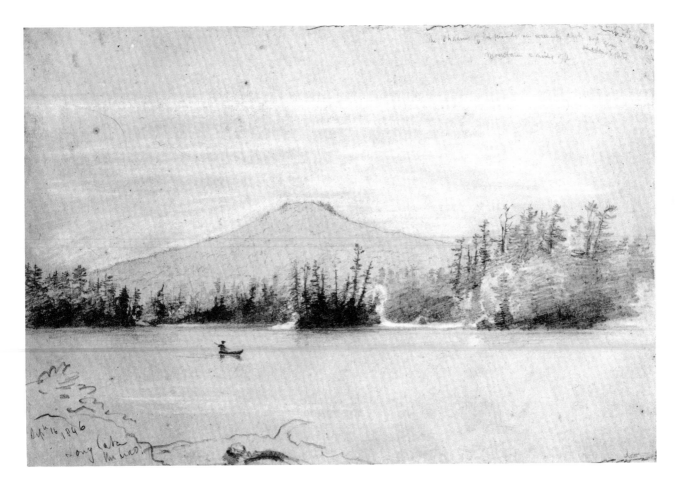

Exhibition: Plattsburgh, N.Y., State University College, Myers Fine Art Gallery, 9–30 January 1972, *Adirondack Paintings,* no. 3 (as *Long Lake, Incapoco*).
Gift of Frank Jewett Mather, Jr. (40-83)

The two drawings above were executed on a fortnight trip to the Raquette River area of the Adirondacks. The trip is described by Cole's biographer, Louis Noble, who accompanied him (see Louis Legrand Noble, *The Life and Works of Thomas Cole,* ed. by Elliot S. Vesell, Cambridge, Harvard University Press, 1964, p. 280). The same kind and size of paper and the same media were used for these and the next drawing, which was also done in 1846.

13 *Rocks, Trees, and Dog*

Pencil, white highlights, on gray paper. 0.356 x
0.247 m.

Inscriptions: by the artist, *Hemlocks / red buds
in clusters / tender grass / white blossoms in
bunches / grass & mosses of tender color / rocks
purplish gray with light greenish baby moss /
June 5th 1846 / [. . .].*

Provenance: Mrs. Florence Cole Vincent (the
artist's granddaughter); purchased by the donor
at Cole's Catskill studio.

Exhibition: Princeton 1943, no. 8.

Gift of Frank Jewett Mather, Jr. (40-79)

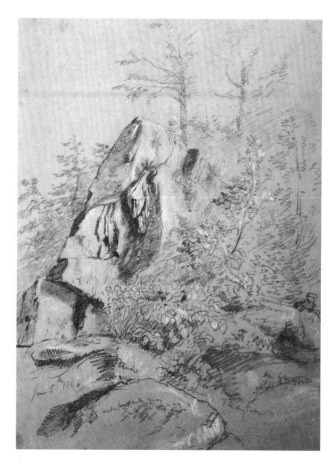

SAMUEL COLMAN

Portland, Maine 1832–1920 New York City

14 *Mountain Landscape, Au Sable*

Pen and brown ink, white and colored washes, on gray paper. 0.273 x 0.39 m.

Inscriptions: lower left in brown ink by the artist, *Au Sable. Aug 1869;* in darker brown ink, *by Saml. Colman / 17*[?].

Gift of Frank Jewett Mather, Jr., in the 1940s (76-23)

The attribution of this drawing has been doubted because of the peculiarities of the signature: the preposition before and undeciphered date or initials after the artist's name, and the darker ink color. The signature *by Saml. Colman,* as a later addition, however, has been found on other drawings by the artist. Colman was a regular summer visitor to the northern Adirondacks, where the name Au Sable (or Ausable) is applied to several geographic entities. His *Sketch from Nature—Ravine of the Ausable, Adirondacks* was included in the catalogue of the American Water-Color Society's third annual exhibition, 1869–70 (no. 422).

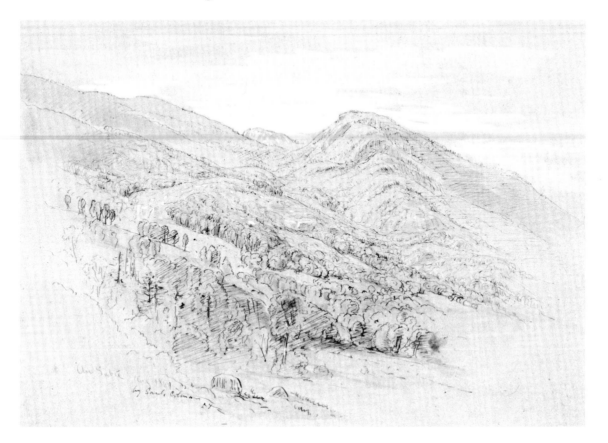

JOHN SINGLETON COPLEY

Boston? 1738–1815 London

The following drawings are two of eighty known sheets of studies, most of them in black chalk on blue paper, for a massive historical painting on which Copley worked from 1783 to 1791. The painting commemorates the 13 September 1782 naval victory of the British over the Spanish at Gibraltar, and it now hangs in the Guildhall Art Gallery, London.

15 Study for the Helmsman in "The Siege of Gibraltar"

Verso: *Study for the Wounded Strokesman*

Black chalk, white highlights, on blue paper. Verso: black chalk. 0.362 x 0.182 m.

Inscription: lower left in pencil, *Siege of Gibraltar.*

Provenance: Lord Lyndhurst (the artist's son); his sale, Christie's, London, 26–27 February 1864, no. 661; Sir Edward Basel Jupp, London; Linzee Amory (son of Martha Babcock Amory, the artist's granddaughter), Boston (see Prown, p. 410); Harry Shaw Newman Gallery (Old Print Shop), New York (*Panorama*, 2, 9 May 1947, cover [illus.] and p. 108 [brief description]).

Exhibition: East Lansing, Mich., Michigan State University, 1–21 May 1959, "College Collections" (catalogue?).

Bibliography: Jules D. Prown, *John Singleton Copley,* vol. 2, *In England 1774–1815,* Cambridge, Harvard University Press, 1966, p. 456 and figs. 566, 571.

Museum purchase (49-250)

In the painting, the helmsman and strokesman are at the far left in the longboat of Sir Roger Curtis. This is half of a bisected sheet; very similar drawings are on the other half of the sheet, which is now in the Addison Gallery of American Art, Phillips Academy, Andover, Mass. (Prown 567 and 570).

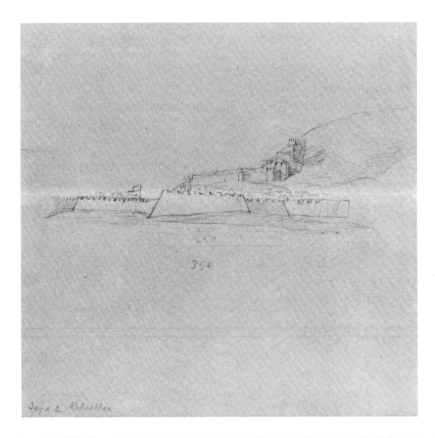

Both recto and verso figures on the Andover half of the sheet are more like those in the finished painting than are the figures on the Princeton half. Prown dates the sheet 1788–89. He describes other studies for the same figures, which are in the Victoria and Albert Museum, London: Prown 572 (Sir Roger and the helmsman rescuing a figure) and Prown 568 (the relation of the wounded strokesman to the oarsman and Sir Roger). Another drawing in the Victoria and Albert Museum (Prown 574) is of the entire longboat.

16 Fortifications: Study for "The Siege of Gibraltar"

Soft pencil, white highlights, on blue paper. 0.323 x 0.285 m.

Inscriptions: lower center, *feet / 250 / 350;* lower left, *Siege of Gibralter.*

Provenance: Lord Lyndhurst; his sale, Christie's, London, 26–27 February 1864, no. 661; Sir Edward Basel Jupp, London; Linzee Amory, Boston; Harry Shaw Newman Gallery (Old Print Shop), New York.

Bibliography: Prown, *John Singleton Copley,* vol. 2, *In England 1774–1815,* pp. 450–51 and fig. 529.

Museum purchase (49-251)

This study was not used in the final painting. Prown dates this sketch between 1783 and 1786, and indicates that it may be after eyewitness accounts or sketches as opposed to a published secondary source, since the artist indicated to the Committee on General Purposes in 1787 that he had "sent persons abroad to take an exact view of the Rock of Gibraltar" at considerable expense. Prown also indicates that because of its sketchy nature, it is difficult to be certain that the drawing is by Copley.

KENYON COX

Warren, Ohio 1856–1919 New York City

17 *Drapery Study for Female Figure in "The Blessing of Sleep"*

Pencil. Squared for transfer. Watermark: *EGYP-TIAN LINEN / Geo B. Hurd & Co.* 0.505 x 0.21 m.

Inscriptions: across top by the artist, *"The Bless-ing of Sleep" Drapery study for female fig-ure / 1899;* lower right by the artist, *Kenyon Cox.*

Provenance: Weyhe Gallery, New York; pur-chased by Dan Fellows Platt, 1937 (pencil note on verso).

Dan Fellows Platt Collection (no. Q 80); his stamp (Lugt 750a) on verso, lower left (48-965)

The subject of this drawing was used on a poster to advertise Paine's Celery Compound, a patent medi-cine soporific. The Cooper-Hewitt Museum, New York, has five studies by Cox for the same composi-tion, which pictures a female figure ("Sleep") stand-ing before a male figure reclining on a bed. The poster is a woodcut printed in black and white. After the artist's return to New York from Europe in 1882, he produced several allegorical paintings, often with classic nudes, for which he could find no purchasers. Here he seems to have found a market-able use for one of these compositions.

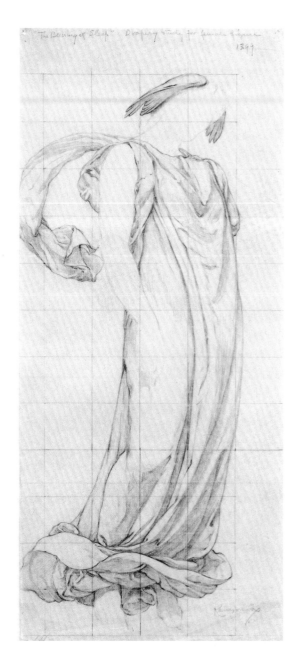

18 Falling Devil: Study for an Illustration in "Paradise and the Peri"

Charcoal. Watermark: *J. Whatman*. 0.537 x 0.385 m.

Inscriptions: lower right in pen and black ink by the artist, *Study for falling devil—Paradise and the Peri— / Kenyon Cox—1884* [in pencil]; at figure's right elbow, *high lights*.

Provenance: Weyhe Gallery, New York; purchased by Dan Fellows Platt, 1937 (pencil note on verso).

Exhibition: Binghamton, N.Y., State University of New York, University Art Gallery, New York, Finch College Museum of Art, and Williamstown, Mass., Sterling and Francine Clark Art Institute, 1974, *Strictly Academic,* no. 51 (illus.).

Dan Fellows Platt Collection (no. Q 81); his stamp (Lugt 750a) on verso, lower left (48-9)

19 The Peri: Study for an Illustration in "Paradise and the Peri"

Charcoal. 0.253 x 0.338 m.

Inscriptions: center left in pencil by the artist, *Kenyon Cox;* below this by the artist, *for "Paradise and the Peri—" / 1884.*

Provenance: Weyhe Gallery, New York; purchased by Dan Fellows Platt, 1937 (pencil note on verso).

Exhibition: Binghamton 1974, no. 50 (illus.).

Dan Fellows Platt Collection (no. Q 83); his stamp (Lugt 750a) on verso, lower left (48-10)

The above drawings are both studies for a series of handsome watercolors, present location unknown, which were reproduced by a photographic process, printed alternately in blue and brown, in a special gift edition of Thomas Moore's *Lalla Rookh: An Oriental Romance* (Boston, Estes and Lauriat, 1885). "Paradise and the Peri" is the title of part two of this lengthy poem. Several other painters contributed to this edition; all of the artwork is curiously unadapted to book illustration. This dichotomy is particularly strange in the case of Cox, who was a competent book illustrator, as several drawings by him in the Princeton collection, but not included in this selection, demonstrate. It is unusual to see life studies used for book illustrations. The *Falling Devil* is a study for the lower of two winged figures who, threatened by an angel above, tumble down the margin on page 111 of Moore's poem. The illustration refers to a descriptive passage on a later page: "Rapidly as comets run / To the'embraces of the sun, / Fleeter than the starry brands / Flung at night from angel hands / At those dark and daring sprites / Who would climb the'empyreal heights. . . ." *The Peri* is a study for the winged figure that appears at the top of page 126, who is reaching down to a child standing below. The text reads: "When, o'er the vale of Balbec winging / Slowly, she sees a child at play. . . ." [Richard Murray has helped considerably with the Cox identifications.]

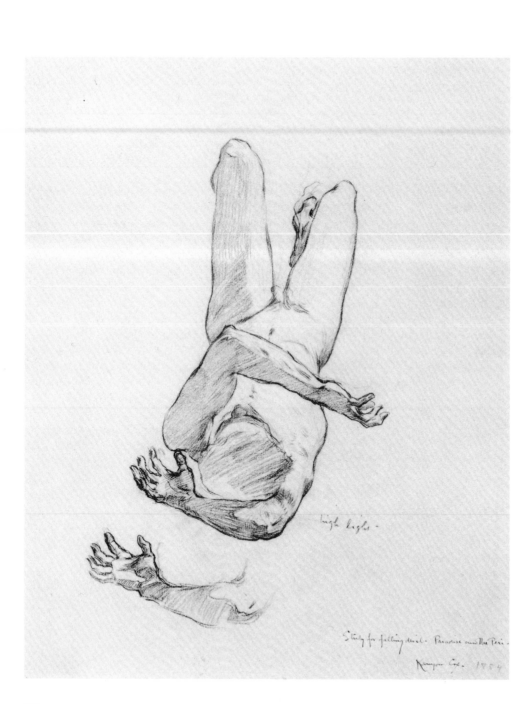

high light

Study for falling devil - Paradise and the Peri

Kenyon Cox - 1884

20

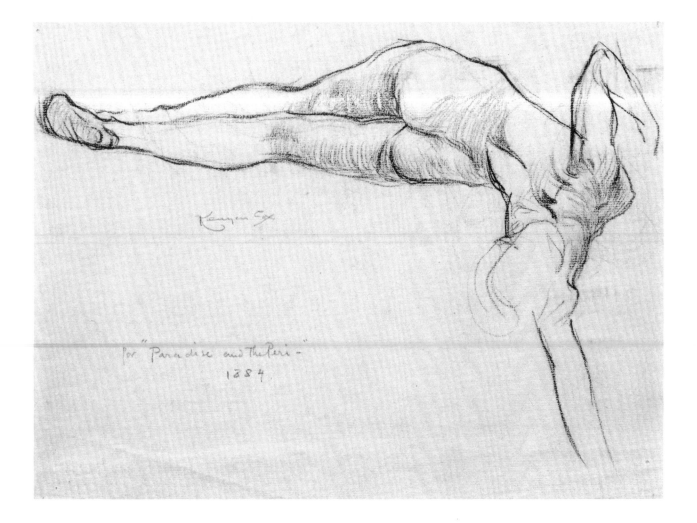

For "Paradise and the Peri —"
1884

21

JASPER FRANCIS CROPSEY

Rossville, Staten Island, N.Y. 1823–1900 Hastings-on-Hudson, N.Y.

20 *Dead Tree*

Pencil, white highlights, on light brown paper. 0.237 x 0.315 m.

Inscription: lower right in pencil by the artist, *J.F.C. 1855.*

Gift of Frank Jewett Mather, Jr. (48-1786)

In 1855 the artist visited Ann Arbor, Michigan, and returned home by way of Lake Erie, the Saint Lawrence River, Montreal, Lake Champlain, and the White Mountains. This drawing, which is characteristic of his work at the time, is probably an observation from nature made along the way.

21 *Cliff at Bonchurch*

Pencil, white highlights, with yellow, reddish brown, and green watercolor, on light brown paper. 0.414 x 0.57 m.

Inscription: lower center in pencil by the artist, *J. F. Cropsey. Bonchurch / Aug. 1859.*

Provenance: purchased from Victor D. Spark, New York.

Exhibition: Cleveland, Ohio, Cleveland Museum of Art, Utica, N.Y., Munson-Williams-Proctor Institute, and Washington, D.C., National Collection of Fine Arts, 1970–1971, *Jasper F. Cropsey 1823–1900* (essay by William S. Talbot), no. 32.

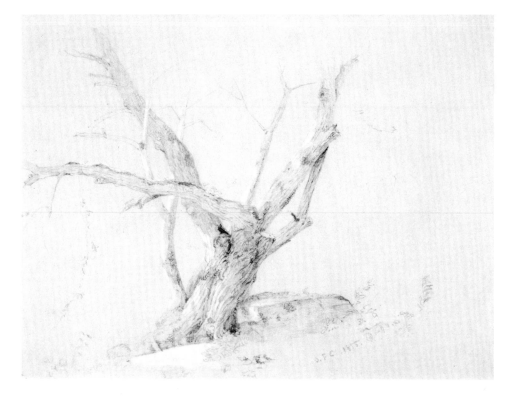

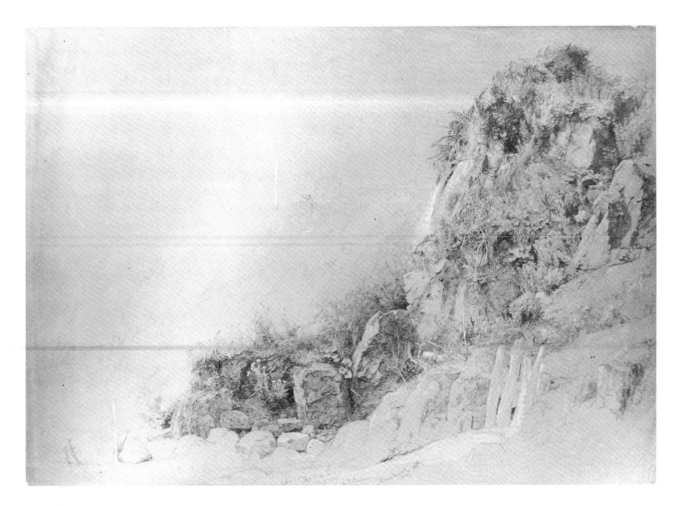

Museum purchase, Laura P. Hall Memorial Fund
(48-1795)

Done on a summer excursion to Bonchurch during an English sojourn, between 1856 and 1863, this drawing directly corresponds to the right half of the composition of Cropsey's oil painting *Beach at Bonchurch, Isle of Wight,* dated 1859. The building and fence indicated sketchily in the drawing are finished in the painting.

Attributed to
ASHER BROWN DURAND

Jefferson Village (now Maplewood), N.J. 1796–1886 Maplewood, N.J.

22 *Venus and Cupid*

Pencil, watercolor. 0.201 x 0.273 m.

Inscriptions: lower right in pencil, *A. B. Durand;* in pen and brown ink, *1834;* lower margin in pen and brown ink, title as given.

Provenance: Max A. Goldstein (Lugt 2824, with *Am. 9* above in pen and black ink); his sale, American Art Association, 2 March 1920, no. 225 (with note: "From the George Jones Dramatic Collection"); purchased by the donor (Lugt 1853a).

Exhibition: Princeton 1943, no. 4.

Gift of Frank Jewett Mather, Jr. (43-12)

The year 1834 marks the transition between Durand's career as a steel engraver and copiest and his becoming a serious painter. It was in this year, too, that he engraved his popular nude *Ariadne* after a painting by John Vanderlyn. There is no apparent explanation for the primitive ineptness of this drawing. Durand's earlier preparatory drawings for his steel-engraved banknotes, many of which are in the New York Public Library, show him to be a competent draftsman with enough understanding of anatomy to give poor Venus two legs. Perhaps Durand began the drawing in a weak moment and it was "finished" by another person, possibly his son. The signature could be genuine.

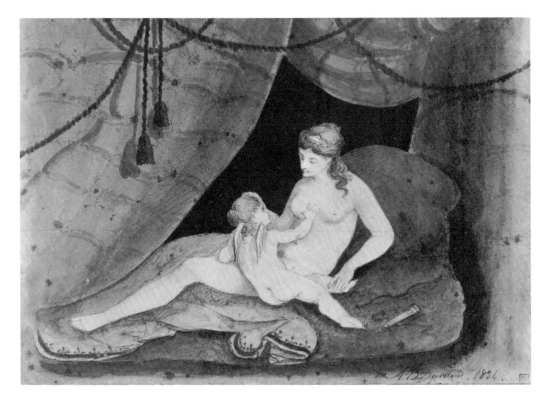

THOMAS EAKINS
Philadelphia 1844–1916 Philadelphia

23 *Seventy Years Ago*

Watercolor over pencil. Borderlines in pencil. Watermark: *J. Whatman.* 0.398 x 0.274 m. Page from Philadelphia *Ledger,* 3 May 1877, behind picture in former frame.

Inscription: upper right in black ink by the artist, *EAKINS / 77.*

Provenance: purchased from the artist by R. D. Worsham, 1878; James P. Silo, New York; purchased by Frank Jewett Mather, Jr., ca. 1928; his estate.

Exhibitions: Philadelphia, Pennsylvania Academy of Fine Arts, 3 December 1877–12 January 1878, *A Collection of Water-Color Drawings Loaned . . . ,* no. 283 (lent by the artist); New York, American Water-Color Society, 11th annual exhibition, February 1878, no. 237; New York, Whitney Museum of American Art, *A History of American Watercolor Painting,* 27 January–25 February 1942, no. 116 (this exhibition was circulated by the American Federation of Arts as its exhibition no. 10, 1945–1946, to Utica, N.Y., Munson-Williams-Proctor Institute, Baltimore, Md., Baltimore Museum of Art, and San Francisco, M. H. de Young Museum; each museum issued a type-written checklist); Washington, D.C., National Gallery of Art, Chicago, Art Institute of Chicago, and Philadelphia, Philadelphia Museum of Art, 1961–1962, *Thomas Eakins: A Retrospective Exhibition,* no. 33 (illus.); Ithaca, N.Y., Cornell University, Andrew Dickson White Museum of Art, 26 May–23 June 1967, untitled exhibition of 18th- and 19th-century American painting; Washington, D.C., Corcoran Gallery of Art, 3 May–10 June 1969, *The Sculpture of Thomas Eakins* (by Moussa M. Domit), no. 11 and p. 44 (illus.); New York, Whitney Museum of American Art, 22 September–21 November 1970, *Thomas Eakins: Retrospective Exhibition* (by Lloyd Goodrich), no. 28.

Bibliography: Alan Burroughs, "Catalogue of Work by Thomas Eakins (1869–1916)," *The Arts,* 5, no. 6, June 1924, p. 329 (as belonging to R. D. Morsham [*sic*]); Lloyd Goodrich, "Catalogue of the Works of Thomas Eakins," *Pennsylvania Museum Bulletin,* 25, no. 133, March 1930, p. 20 (incorrect double listing as nos. 56 and 57); Lloyd Goodrich, *Thomas Eakins: His Life and Work,* New York, Whitney Museum of American Art, 1933, p. 171 and no. 114 ("Catalogue of Works"); Margaret McHenry, *Thomas Eakins Who Painted,* n.p. [Philadelphia?], 1946, p. 35 (mentioned); Donelson F. Hoopes, *Eakins Watercolors,* New York, Watson-Guptill, 1971, p. 40 and pl. 10 (color); Ellwood C. Parry III and Maria Chamberlin-Hellman, "Thomas Eakins as an Illustrator, 1878–1881," *American Art Journal,* 5, no. 1, May 1973, p. 30 (mentioned); Gordon Hendricks, *The Life and Work of Thomas Eakins,* New York, Grossman, 1974, pp. 111–12, fig. 92, and no. 160 ("Checklist").

Gift of Mrs. Frank Jewett Mather, Jr. (57-118)

This is one of several works painted around 1880 in which Eakins tried to evoke the past. The sitter has been identified as Mrs. "Aunt Sallie" King, a relative of the Crowell family into which Eakins' sister married. The same model was painted from a different angle in the oil *William Rush Carving His Allegorical Figure of the Schuylkill River* of 1877. The subject was used again by the artist in his bronze bas-relief *Knitting,* circa 1883. The sculpture is pendant to another called *Spinning,* which is after a watercolor of 1881 that has the same title. Eakins is an artist whose watercolors are as important as his oil paintings. This is a splendid example of a watercolor conceived as an independent work of art.

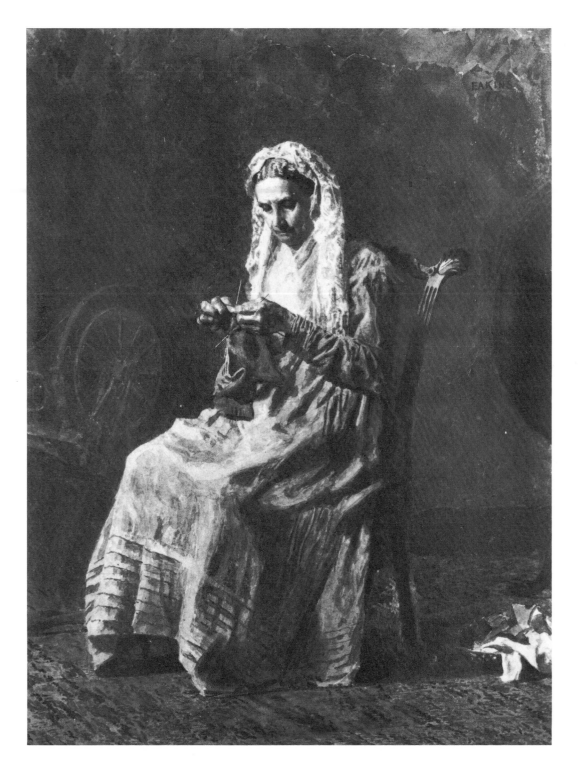

WYATT EATON

Phillipsburg, Quebec, Canada 1849–1896 Newport, R.I.

24 *Seated Nude Arranging Her Hair*
Verso: *Study of Skirt and Knees*

Charcoal on gray paper. Watermark: *MÉRET.* 0.291 x 0.226 m.

Inscription: lower left in pen and ink, *Study by Wyatt Eaton* / [signed] *Charlotte Eaton.*

Gift of Frank Jewett Mather, Jr., in the 1940s (76–25)

The style of this drawing and the French watermark suggest that it was made during the artist's early years in France. Eaton shows here his indebtedness to Millet, near whom he lived in Barbizon. The Museum has another drawing by Eaton, identified as a sketch for *The Reader,* which is not included in this catalogue.

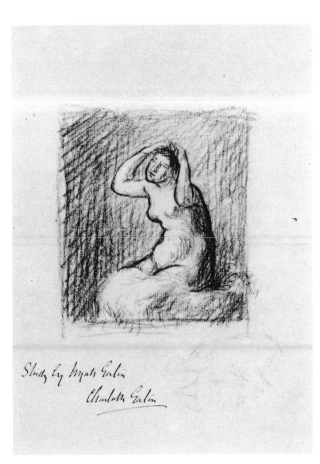

JOHN WHETTEN EHNINGER

New York City 1827–1889 Saratoga Springs, N.Y.

25 *Children's Parade*

Pen and black ink over slight brown and black pen-
 cil. 0.26 x 0.37 m.
Inscription: lower left by the artist, *John W. Ehnin-
 ger / 1860.*
Source not recorded; probably gift of Frank Jewett
 Mather, Jr. (43-138)

Ehninger was equally competent as an illustrator
and a painter in oils. This drawing could be prepara-
tory to either a canvas or a lithograph, since his
drawings for either medium were similar in both
technique and subject matter.

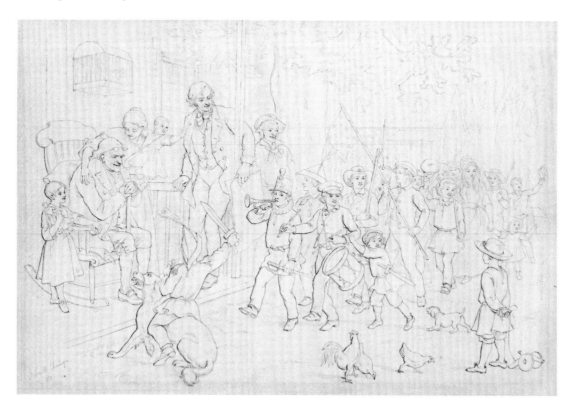

CHARLES BALTHAZAR JULIEN FÉVRET DE SAINT-MÉMIN

Dijon, France 1770–1852 Dijon, France

26 *Portrait of Richard Hatfield*

Black pastel, white highlights, over pencil, on pink-washed paper. 0.486 x 0.38 m. (corners cut away). In original gold-leaf frame, with octagonal border painted on the glass in black, brown, and gold.

Bequeathed to Princeton University Library by Mrs. Mollie K. Schroeder in the name of her husband, Nathan S. Schroeder, Class of 1898; transferred to The Art Museum (72-32)

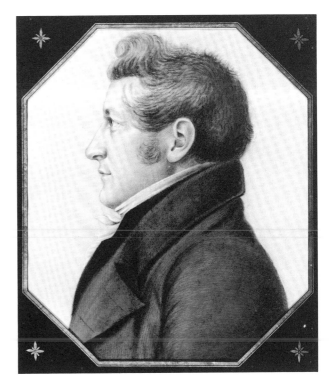

Although a Frenchman and self-trained, this artist merits inclusion here because his professional career and subjects were entirely American and because of his use of a curious mechanical device called a physionotrace. Févret de Saint-Mémin traced the silhouette of his sitter's features with a pencil, using an ingenious portable frame. The resulting sketches were finished by hand in black pastel and called ''crayons.'' For these the artist charged eight dollars. Twenty-five dollars (thirty-five for women) would purchase one ''crayon'' in a frame made and decorated by the artist, a copper plate on which the drawing had been reduced with the aid of a pantograph and engraved, and twelve engravings. Since Hatfield's portrait is not recorded in lists of the artist's engravings, we can assume he ordered only the ''crayon.'' The sitter is an ancestor of Mr. Schroeder. The portrait can be dated between 1796 and 1810, the artist's active period; it is likely that it was done before 1803, when he left the New York–Philadelphia area to go south.

ALVAN FISHER

Needham, Mass. 1792–1863 Dedham, Mass.

27 *Niagara Falls with Night Fishermen*

Black, gray, and white wash over pencil. 0.215 x 0.373 m.
Exhibition: Princeton 1943, no. 5.
Gift of Frank Jewett Mather, Jr. (43-13)

28 *Niagara Falls with Rainbow*

Pencil, gray wash. Rainbow is an erasure. Squared for transfer in pencil. Watermark: *SMITH & ALLNUTT*. 0.275 x 0.397 m.

Gift of Frank Jewett Mather, Jr. (43-14)

Niagara Falls is the subject of several works executed by Alvan Fisher following an excursion there in July 1820; it is not known if he made subsequent trips. His landscapes, known for the small figures engaged in various pursuits, were painted from memory in his studio with the aid of sketches made earlier at the scene. The first drawing above, a not altogether successful attempt at a night scene, is undoubtedly a studio production; the second could be from nature, with later additions. Oil paintings exist that are very similar, except in small details, to both of these drawings.

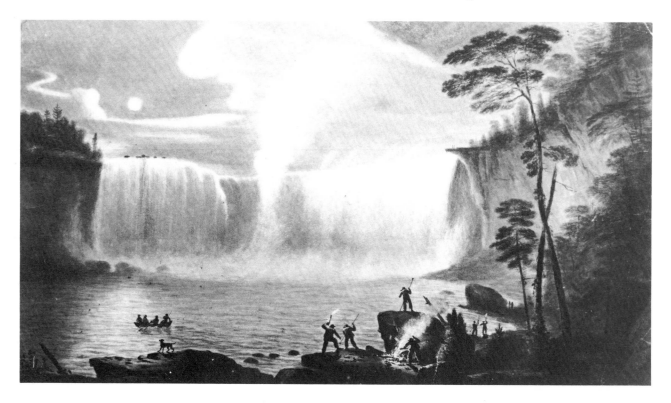

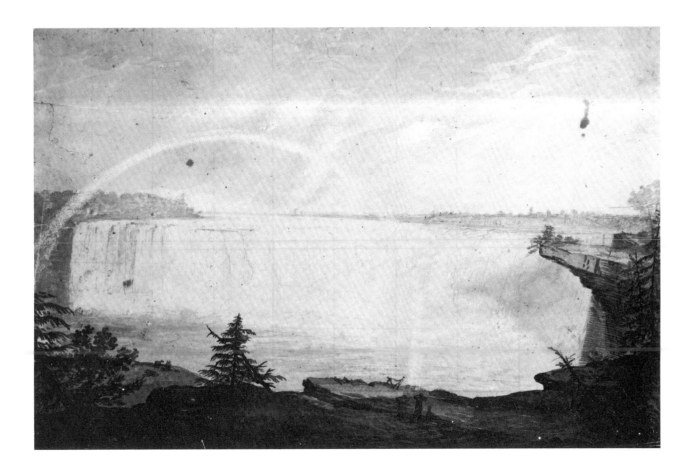

LILIAN WESTCOTT HALE

Hartford, Conn. 1881–1963 Dedham, Mass.

29 *Portrait of Agnes Doggett, Later Mrs. Charles Ruddy*

Charcoal and pencil. Blindstamp: *Strathmore Drawing Board*. 0.741 x 0.585 m.
Inscription: center left in pencil by the artist, *Lilian Westcott Hale*.
Provenance: the artist's family; Hirschl and Adler, New York.
Gift of the Friends of The Art Museum (69-398)

The artist, the portrait painter wife of Philip Leslie Hale, maintained a studio at their home in Dedham, Mass., while Mr. Hale commuted to a studio in Boston. According to a letter dated 9 January 1976 from Nancy Hale Bowers, the artist's daughter, the sitter for this portrait lived up the road from the Hales when she was a young woman: "Mother . . . found Agnes enormously paintable and used her as a model repeatedly. . . . There is a painting, of the same pose, and I don't know where it is." Special attention should be given to Mrs. Hale's remarkable ability to render sensitively different materials and textures. Her drawing style was consistent, making it difficult to date her works; judging from the age of the sitter and information in the letter quoted above, it was probably drawn circa 1915.

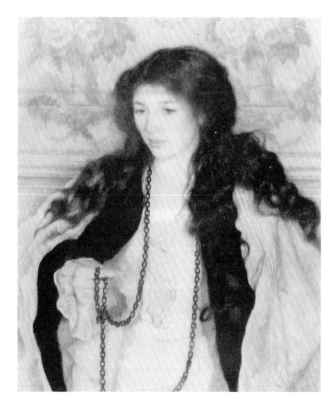

PHILIP LESLIE HALE

Boston 1865–1931 Boston

30 *Female Nude with Raised Arms*

Red crayon. Watermark: *Lalanne*. 0.453 x 0.301 m.
Gift of Stuart P. Feld, Class of 1957, and Mrs. Feld
 (72-37)

This sketch, which dates from the mid-1920s, is a
study for the oil *Girl and Gulls,* also known as *Aph-
rodite of the Sea Gulls.* The painting, which was
shown in the 1928 annual exhibition of the Pennsyl-
vania Academy of Fine Arts, depicts a nude girl, in
the same position as in the drawing, surrounded by
flying birds. The artist's daughter, Nancy Hale
Bowers, writes in a letter dated 9 January 1976, "it
was my father's habit to make a great many studies
for any painting, in many different mediums." The
painting is reversed from this study, indicating that
a tracing process was involved in the sequence. Re-
versed studies for other paintings by Hale have
been recorded.

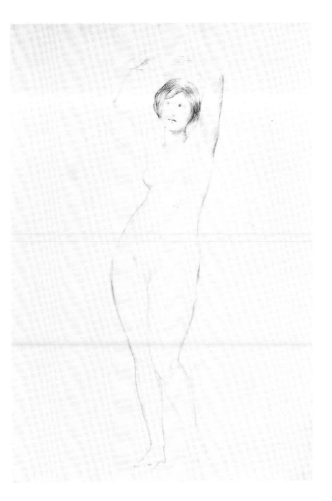

JAMES McDOUGAL HART

Kilmarnock, Scotland 1828–1901 Brooklyn, N.Y.

31 *Forest and Rail Fence*

Pencil. Watermark: *J. Whatman 1855.* 0.25 x 0.36 m.
Inscription: lower left in pencil, erased and no lon-
ger legible.
Provenance: Hirschl and Adler, New York.
Gift of Stuart P. Feld, Class of 1957, and Mrs. Feld
(74-27)

This is an early drawing by Hart, probably from his
Albany period, between 1853 and 1857. It shows a
sensitivity to nature and attention to detail. These
qualities are lost in his later rustic, beautified land-
scapes, in which he catered to the popular taste of a
rising middle class in New York City.

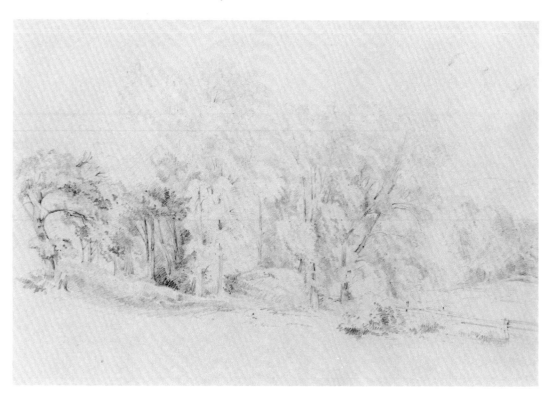

ERNEST HASKELL

West Woodstock, Conn. 1876–1925 Maine

32 *Portrait of a Boy*

Black crayon, touches of red on lips and mouth, on olive gray paper. 0.314 x 0.208 m.

Inscriptions: lower left, blindstamp of a crab and initials *E. H.* in oval; lower right, blindstamp, *Ernest Haskell,* with *1900* above in pen and ink; above these, unidentified stamp (of the artist?) printed in gray and green.

Bibliography: Ernest Haskell, Jr., [*Ernest Haskell:*] *Permanent Collections,* West Point, Maine, 1948, n. pag. (listed on 12th page).

Gift of Frank Jewett Mather, Jr. (44-534)

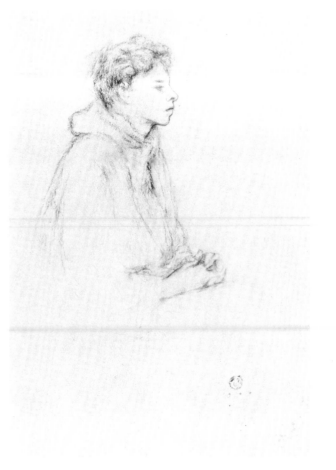

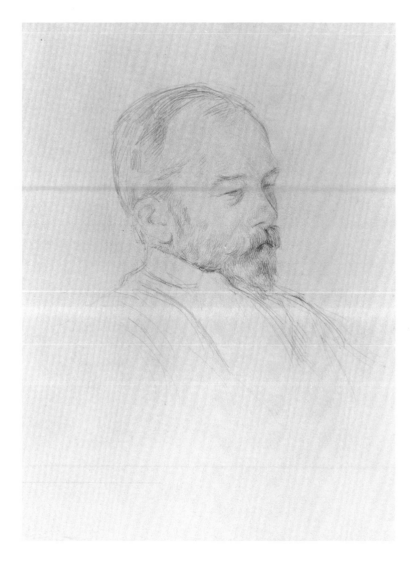

33 *Dr. Mather*

Silverpoint. 0.171 x 0.125 m.
Bibliography: *Record of The Art Museum, Princeton University,* 5, no. 2, 1947, p. 2 (illus.); Haskell, *Permanent Collections,* n. pag. (listed on 12th page).
Gift of Frank Jewett Mather, Jr. (43-22)

This portrait of Frank Jewett Mather, Jr., was drawn at the sitter's cottage at Sebasco, Maine, in 1911. The artist and Mather were good friends. Both drawings by Haskell included here demonstrate the artist's considerable interest in the techniques of printmaking. *Portrait of a Boy* has a decided Whistlerian quality, and the stamps and devices on it are typical of those used by exponents of the etching movement in America in the first quarter of this century. Haskell produced oils and watercolors, notably portraits and landscapes, but it is probably for his etchings that he will be remembered.

CHILDE HASSAM

Dorchester, Mass. 1859–1935 New York City

34 *View in Monmartre, Paris*

Watercolor over pencil. 0.353 x 0.252 m.
Inscription: lower left in pen and black ink by the
 artist, *Childe Hassam. Paris 1889.*
Gift of Stuart Riddle Stevenson, Class of 1918
 (57-117)

Hassam lived at 11 Boulevard de Clichy near the
Place Pigalle from the end of 1885 to the beginning
of 1889. This scene could well be on this street,
looking toward Paris with the Cimetière Monmartre
just uphill behind; the funeral cortege lends cre-
dence to this speculation.

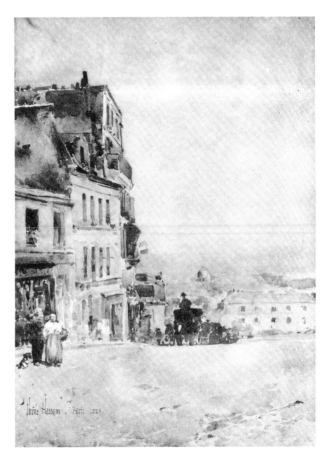

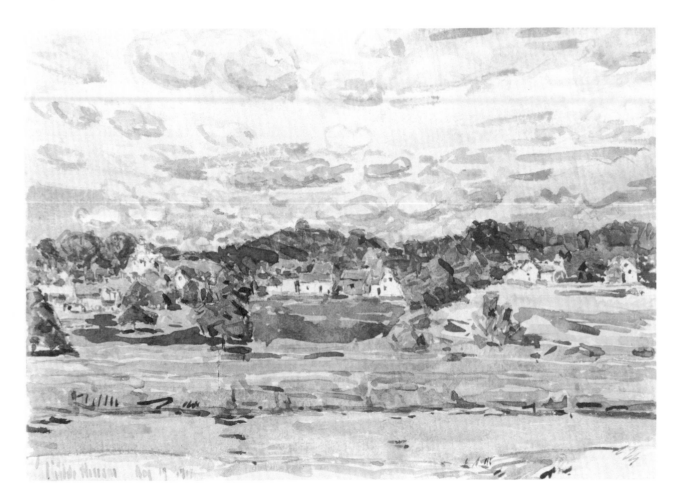

35 *Newfields, New Hampshire*

Watercolor over pencil. 0.252 x 0.352 m.
Inscription: lower left in brush and green water-
color by the artist, *Childe Hassam Aug 19 1917*.
Gift of the American Academy of Arts and Letters
(44-566)

The town of Newfields is observed across the
Squamscot River from the Whitcomb Farm in Stra-
tham, where Hassam spent several summers. This
view was a favorite subject for the artist. Very sim-
ilar versions are in the Currier Gallery of Art, Man-
chester, N.H. (dated 1906) and the John Herron Art
Institute, Indianapolis (1917). Hassam also made
an etching with the same title, dated September
1916.

JOHN HENRY HILL

West Nyack, N.Y. 1839–1922 West Nyack, N.Y.

36 *Landscape, Long Island*

Watercolor over pencil. 0.228 x 0.305 m.
Provenance: Harry Shaw Newman Gallery (Old
 Print Shop), New York.
Museum purchase (44-227)

According to a pencil note on the former mount,
this work was executed around 1870, perhaps just
after Hill returned from a western expedition with
Clarence King in 1868. This landscape, in which the
light seems to flicker and the paint is richly colored
and thickly applied, is typical of Hill's handsome
watercolors.

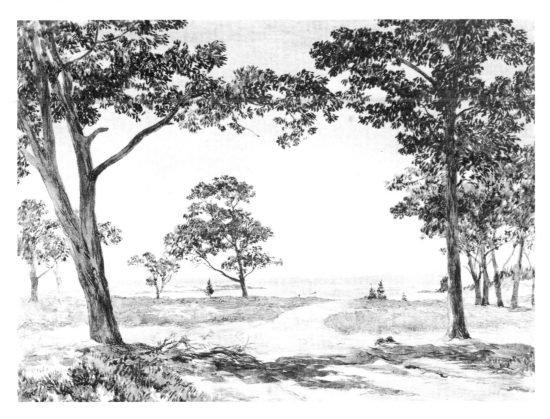

WINSLOW HOMER

Boston 1836–1910 Prouts Neck, Maine

37 *Swinging on a Birch Tree*

Pencil, white highlights, on brown paper. Outlines
 are incised. 0.222 x 0.12 m.
Provenance: Giovanni Castano, Boston, 1937; pur-
 chased by the donor.
Gift of Frank Jewett Mather, Jr. (43-24)

This drawing is preparatory to a wood-engraved il-
lustration for a poem by Lucy Larcom in *Our
Young Folk,* 3, June 1867, opp. p. 321. The wood
engraving was published again in Lucy Larcom's
Childhood Songs (Boston, J. R. Osgood, 1875). The
incised lines on the drawing indicate that Homer
probably traced it directly onto the woodblock.
Homer used the same subject in an oil painting
called *Boys on a Bough* in 1864, which is also proba-
bly the date of the present drawing.

38 *Eastern Point Light*

Watercolor over pencil. 0.245 x 0.34 m.
Provenance: the artist to Charles S. Homer (his
 brother); Mrs. C. S. Homer; Charles L. Homer
 (her nephew); Hirschl and Adler, New York; pur-
 chased by the donor, March 1956.
Exhibitions: New York, American Water-Color So-
 ciety, 14th annual exhibition, February 1881, *Il-
 lustrated Catalogue,* no. 540 (review in *The Na-
 tion,* 32, 3 February 1881, p. 80); Prouts Neck,
 Maine, Prouts Neck Association, 1936, *Century
 Loan Exhibition as a Memorial to Winslow
 Homer,* no. 7 (illus.) (incorrectly identified as
 Schooners at Sunset, 1880, the title and date of a
 similar watercolor now in the Fogg Art Museum);
 probably Brunswick, Maine, Bowdoin College
 Museum of Art, and Waterville, Maine, Colby
 College Art Museum, 1954 (as *Schooners in the
 Moonlight, Saco Bay, 1885*) (according to L.

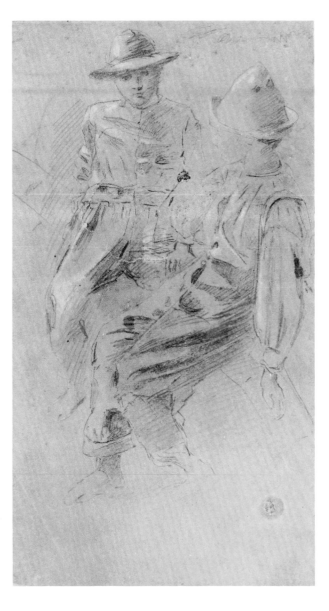

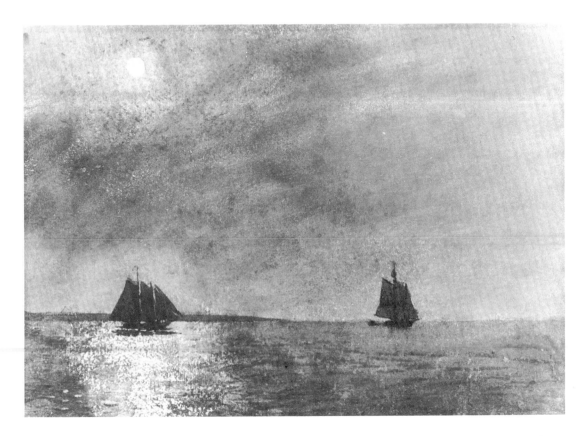

Goodrich) (catalogue?); Washington, D.C., National Gallery of Art, and New York, Metropolitan Museum of Art, 1958–1959, *Winslow Homer: A Retrospective Exhibition,* no. 102; Wellesley, Mass., Wellesley College, 1976, "Gloucester Watercolors of Winslow Homer," review in *Wellesley Alumnae Magazine,* spring 1976, p. 9 (illus.).

Bibliography: Theodore Bolton, "Water Colors by Homer: Critique and Catalogue," *Fine Arts,* 18, no. 5, April 1932, p. 20 (listed); William Howe Downes, *The Life and Works of Winslow Homer,* Boston and New York, Houghton Mifflin, 1911, p. 94 (mentioned); Albert Ten Eyck Gardner, *Winslow Homer, American Artist: His World and His Work,* New York, Clarkson N. Potter, 1961, p. 94 (illus.).

Gift of Alastair B. Martin, Class of 1938 (57-116)

The subject of this work is Gloucester Harbor on the Massachusetts coast, with Eastern Point lighthouse in the distance, at the left. The artist made the New England coastline the frequent subject of paintings and drawings. This watercolor, which has also been called *Moon over Eastern Point* and *Moonlight, Bluff Island,* was painted in 1880.

39 *Women on a Rocky Shore*

Charcoal, white highlights. 0.193 x 0.318 m.
Inscription: lower right by the artist, *HOMER.*
Provenance: purchased from the artist by John
Morse, Needham, Mass., 1882; Charlotte Morse
(his daughter); purchased by the donor from Miss
Morse, 1941.
Exhibition: Princeton 1943, no. 20.
Gift of Frank Jewett Mather, Jr. (43-25)

This drawing and the next one are two of several
charcoal studies of fishermen and the sea made by
Homer at Tynemouth, England, in 1881 and 1882.

The Mussel Gatherers, a watercolor now in the Bal-
timore Museum of Art, has similar central figures
and the same general composition.

40 *After the Storm*

Charcoal, brown crayon, touches of white. 0.29 x
0.212 m.
Inscriptions: lower right by the artist, *H;* lower mar-
gin in pen and brown ink, *New=York—Après
l'Orage—After the Storm. | Exposition au Cen-
tury Club. | Winslow Homer, N. A.*
Provenance: Earl Shinn (who probably added the

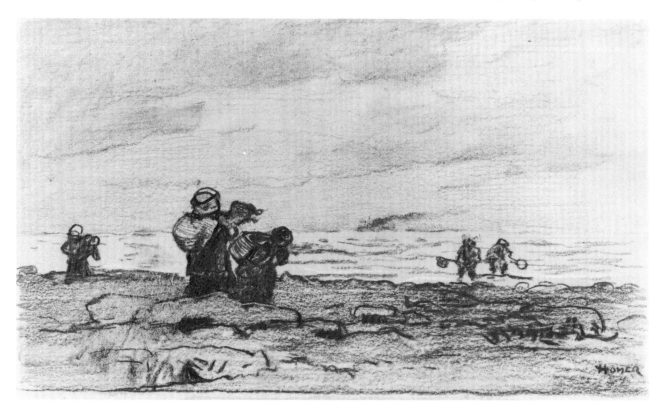

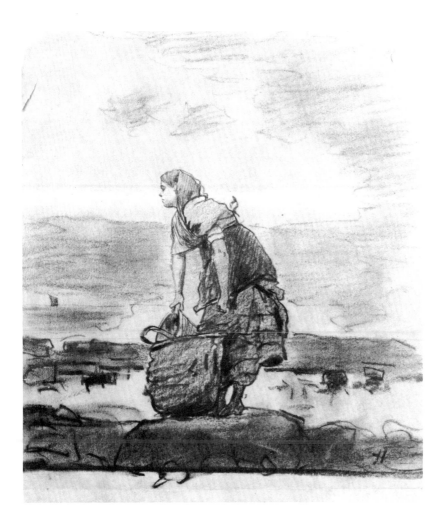

inscription), 1883(?)–1886; bequest to Richard T. Cadbury, Philadelphia (his nephew); bequest to Mrs. Leah Cadbury Furtmueller (his daughter), 1929; gift to Mrs. Henry J. Cadbury, Cambridge, Mass. (her cousin); purchased by the donor, 1947.
Exhibition: New York, Century Association, handwritten exhibitions record (on microfilm at Archives of American Art), entry for 3 March 1883, no. 44 (as *After a Storm*).
Gift of Frank Jewett Mather, Jr. (49-149)

A watercolor version of the same subject, called *The Wreck* or *Girl with Red Stockings* and dated 1882, is in the Museum of Fine Arts, Boston.

41 *Feeling the Enemy*

Pen and black ink, soft pencil; erasures whitened with ink, apparently to delete an earlier horizon line and certain areas on second figure from left. 0.29 x 0.485 m.
Inscription: lower right in black chalk by the artist, *W.H.*
Provenance: E. Greenburg, New York; purchased by Robert W. Macbeth, New York, January 1937 (as *Civil War Study*); purchased by the donor, 17 February 1939.
Exhibition: Washington, D.C., Corcoran Gallery

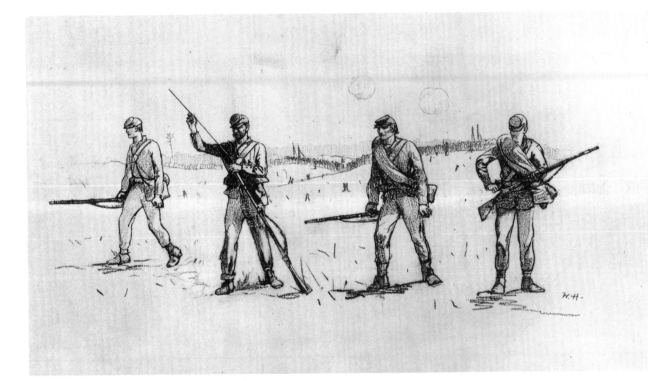

of Art, and Boston, Museum of Fine Arts, 1961–1962, *The Civil War: The Artists' Record* (by Hermann Warner Williams, Jr.), no. 84 and p. 105 (illus.).

Bibliography: *The Laura P. Hall Memorial Collection of Prints and Drawings,* Princeton, Department of Art and Archaeology, Princeton University, 1947, no. 40 (listed); Julian Grossman, *Echo of a Distant Drum: Winslow Homer and the Civil War,* New York, Harry N. Abrams, 1974, p. 70, no. 49 (illus.).

Laura P. Hall Memorial Collection, bequeathed by Prof. Clifton R. Hall (46-263)

This is one of a series of drawings that Homer made between 1887 and 1888 for articles in *Century* magazine, which were later expanded into the four-volume *Battles and Leaders of the Civil War* (edited by R. U. Johnson and C. C. Buel, New York, Century, 1888, vol. 3, p. 224). The drawings were based on eyewitness sketches that Homer had made at the front between 1861 and 1864 on one of several assignments for *Harper's Weekly.* The inspiration for the second-from-left and the right-hand figures can be traced to two drawings made by Homer in 1863–64, now in the Cooper-Hewitt Museum, New York (acc. nos. 1912-12-99 and 1912-12-101). The stiffness of the technique and the whiting-out of lines are consistent with this drawing's purpose, to be copied mechnically for an illustration.

WILLIAM MORRIS HUNT

Brattleboro, Vt. 1824–1879 Appledore, Isle of Shoals, N.H.

42 *Waterside Scene with Cat and Man on a Raft*

Charcoal on tan-washed paper. 0.187 x 0.252 m.
Inscription: lower right by the artist, *WH*.
Gift of Frank Jewett Mather, Jr. (51-127)

It is possible that this is a Venetian scene. The monogram without a middle initial indicates an early date.

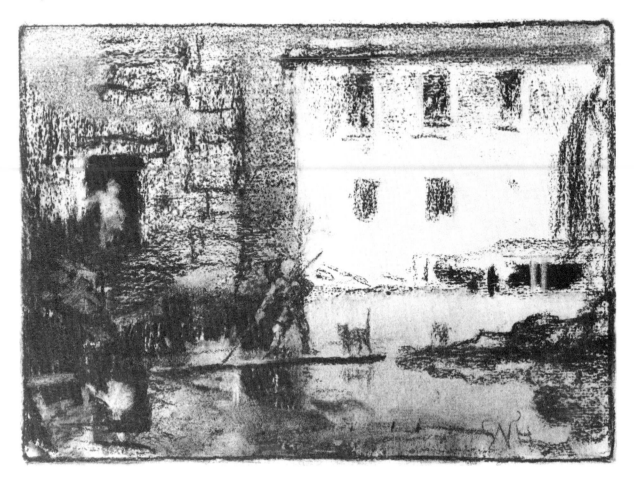

43 *House*

Charcoal on tan-washed paper. 0.22 x 0.274 m.
Inscription: lower left, a mark or monogram?
Exhibition: Princeton 1943, no. 10 (house identified
 as the artist's in Magnolia, Mass.).
Gift of Frank Jewett Mather, Jr. (41-150)

44 *Young Peasant Girl*

Charcoal on buff paper. 0.265 x 0.25 m.
Bibliography: Charles E. Slatkin and Regina Shool-
 man, *Treasury of American Drawings,* New
York, Oxford University Press, 1947, no. 60
(illus.).
Gift of Frank Jewett Mather, Jr. (44-246)

A pencil note on the old mat suggests that this draw-
ing might have been a study for a lithograph.

45 *Portrait of a Young Girl*

Charcoal on blue paper. 0.41 x 0.333 m.
Inscription: lower right by the artist, *WMH*.
Provenance: Giovanni Castano, Boston; purchased
 by the donor.
Gift of Frank Jewett Mather, Jr. (44-546)

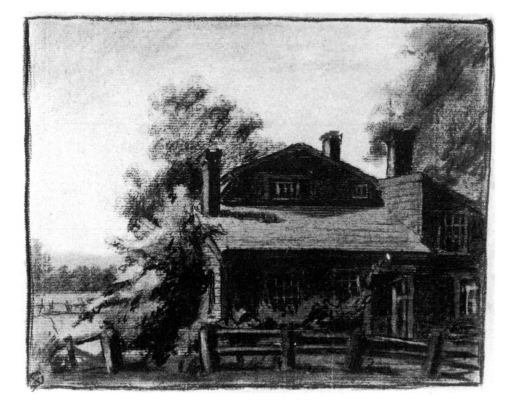

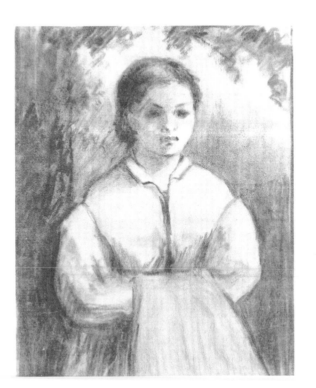

The following drawings are for two large murals, commissioned in 1878 for the Assembly Chamber of the State Capitol in Albany. This was the second major mural project in this country; the first, by John La Farge, was two years earlier at Trinity Church, Boston (see La Farge, nos. 68–70, below). Hunt felt honored to be selected for the Albany project, and he had a sense of being at the culmination of his career. When the two opposite lunette-shaped, 16-by-45-foot walls were ready and the scaffolding in place, the artist began, on 29 October 1878, and worked feverishly, completing the murals in less than two months, with the aid of only one assistant. He worked in oils directly on unprepared sandstone walls. His method was to trace in bold outlines the images of lantern slides cast on the walls and to use one-third size cartoons for the de-

tail. The project ruined Hunt physically and emotionally and he committed suicide the next year. Sadly, too, within ten years the paintings cracked and flaked due to improper materials used and water seepage through the roof. Around 1888 the arched ceiling was found to be structurally unsound, and bracing and a false ceiling were installed, obscuring the murals, which are still in place. The improbable subjects, described below (nos. 46–48), are gallant journeys through the unknown, reflecting the optimism of the post-Civil War period. They have been said to represent opposing forces—negative and positive, night and day, female and male, divine and pagan, superstition and science. It may be more accurate to suppose that Hunt or his supporters successfully rationalized his use of two unrelated subjects that he had

explored previously, thus affording him the opportunity to represent dramatic action and mysterious allegory. An interesting account of the commission, with good reproductions, is in Cecil R. Roseberry, *Capitol Story* (Albany, State of New York, 1964).

46 *Anahita: The Flight of Night*

Charcoal. Watermark: *Lalanne*. 0.295 x 0.43 m.
Inscriptions: lower left by the artist, *WMH;* lower right margin, *anitre* [i.e., Anahita?]—*Flight of night*.
Exhibitions: Princeton 1943, no. 9 and fig. 3; Smithsonian Institution Traveling Exhibition Service (New York, Cooper Union Museum, Munich, Amerika Haus, Rouen, Musée des Beaux-Arts [with catalogue in French], and London, London Tea Centre), 1954, *An Exhibition of American Drawings,* no. 57; Saratoga Springs, N.Y., Skidmore College, Hathorn Gallery, 18 April–5 May 1968, *American Allegorical Paintings, Drawings, and Prints,* no. 10 and back cover (illus.).
Gift of Frank Jewett Mather, Jr. (43-26)

This drawing was inspired by a translation of a traditional Persian poem that Hunt's brother, Leavitt, sent to him in 1846. The subject is the Persian goddess of night, who is riding through the heavens on a chariot of the moon, dispelling darkness—driven from the realm of fantasy and unreality by the dawn of civilization. A man with an inverted torch, who

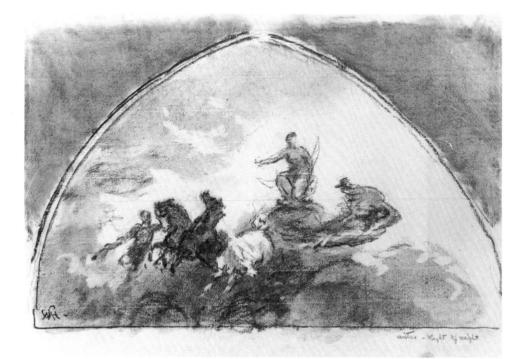

represents medieval resistance to enlightenment, holds back her horses. Hunt had worked on the subject since 1846, producing many sketches and a huge 50-foot-long canvas, all unfortunately lost when the Boston fire of 1872 destroyed his studio. Only three reminders of these works survived the fire: a small photograph of the large canvas, a high-relief plaster sculpture of the three horses (Metropolitan Museum of Art, New York), and a painted tea tray that the artist had given his sister (Museum of Fine Arts, Boston). The conception was well developed by 1878, when Hunt used it in his Albany mural. He simply adapted the subject in a series of charcoal drawings and cartoons, of which this is one, in which he is studying patterns of light and shade and adjusting the composition to the arch shape of the ceiling.

47 *The Discoverer: Composition Study and Figure Sketches*

Charcoal on thin paper; sketch at lower right in pencil. 0.355 x 0.506 m.
Inscription: lower right in charcoal superimposed over drawing, *8. 161* [or *8. 14*].
Gift of Frank Jewett Mather, Jr. (45-83)

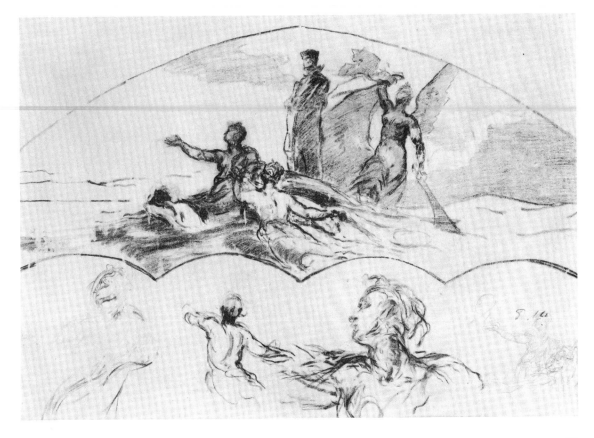

48 *The Discoverer: Two Composition Studies*

Charcoal. Watermark: *AGM*. 0.3 x 0.435 m.
Exhibition: Skidmore College 1968, no. 11.
Gift of Frank Jewett Mather, Jr. (44-547)

In *The Discoverer,* Columbus voyages over un-
known seas, accompanied by Fortune (at the rud-
der), Hope (clinging to the prow, pointing the way),
Science (holding a chart indicating discovery), and
Faith (swimming ahead). The subject had appealed
to Hunt as early as his student days in Couture's
studio in Paris, but was not as fully developed as the
Anahita by 1878, when Hunt used it in the murals

for the Albany Capitol. There exist several studies
in charcoal and in oil for individual figures and vari-
ant compositions. In the first study above (no. 47),
Hunt is working out the disposition and modeling of
the individual figures, particularly those of Hope
and Science. The figures are closer together than in
the finished version. The study of the whole com-
position at the top is probably a tracing from an
earlier version, which has been reinforced with
freer lines. In the second drawing (no. 48), Hunt's
interest is in adapting the composition to the arch
shape, and exploring a seated position for Fortune,
whose figure is more interesting to Hunt than that of
Columbus and tends to dominate the composition in
the finished mural.

HENRY INMAN

Utica, N.Y. 1801–1846 New York City

49 *Rip van Winkle*

Pencil. 0.233 x 0.294 m.

Inscriptions: to left, *Rip van Winkle;* lower center, *Inman.*

Provenance: Thomas Cole (pencil note on former frame); Kende Galleries, sale no. 422, 10 February 1951, no. 63.

Bibliography: William H. Gerdts, ''Inman and Irving: Derivations from Sleepy Hollow,'' *Antiques,* 74, no. 5, November 1958, pp. 420–23 (illus.).

Museum purchase (51-29)

William Gerdts cites two paintings by Inman of Rip van Winkle, one, an early painting of 1823, where the subject is awakening from his sleep, and another made in 1832, which depicts the actor James Henry Hackett in the role of Rip van Winkle. This drawing is not like either painting. Gerdts also mentions a large *Rip van Winkle Arising from His Sleep* painted by Inman in 1845 for the steamboat *Rip van Winkle,* which was destroyed in 1872. It is not impossible that the present drawing is a study for this later work. The drawing is typical of the tentative, delicate pencil sketches Inman made throughout his short career.

JOHN O'BRIEN INMAN

New York City 1828–1896 New York City

50 *Seated Woman*

Watercolor over pencil. 0.355 x 0.25 m.
Inscriptions: lower right in pencil by the artist,
 John[?] *O'B Inman;* across bottom, *First think
 for a figure*.
Gift of Frank Jewett Mather, Jr. (44-213)

John O'Brien Inman, son of the artist Henry
Inman, is noted primarily for his portraits and still
lifes. This is typical of the artist's early works.

GEORGE INNESS

near Newburgh, N.Y. 1825–1894 Bridge-of-Allan, Scotland

51 *Woodland Scene*

Pen and brown ink, brown wash, white highlights, pencil, on greenish gray paper. 0.31 x 0.245 m.
Inscription: lower left in pen and ink (or stamp?), *Inness*.
Exhibitions: Princeton 1943, no. 14; Smithsonian Institution Traveling Exhibition Service (New York, Cooper Union Museum, Munich, Amerika Haus, Rouen, Musée des Beaux-Arts [with catalogue in French], and London, London Tea Centre), 1954, *An Exhibition of American Drawings,* no. 62.

Bibliography: LeRoy Ireland, *The Works of George Inness: An Illustrated Catalogue Raisonné,* Austin, University of Texas Press, 1965, no. 6 (illus.).

Gift of Frank Jewett Mather, Jr. (43-27)

This is one of a few extant drawings by Inness. Ireland dates it between 1845 and 1848, Inness' student period.

EASTMAN JOHNSON

Lovell, Maine 1824–1906 New York City

52 *Sheet of Sketches* (recto and verso)

Pencil on faintly ruled blue paper. 0.318 x 0.402 m.
Inscriptions: lower left, *Augusta, Maine* [and, several times in various styles] *Paul Chandler;* lower right, *Johnson* [three times]; cross-hatching superimposed over sketches at lower left.
Provenance: Albert Rosenthal (according to Baur).
Exhibition and Bibliography: John I. H. Baur, *An American Genre Painter: Eastman Johnson, 1824–1906,* Brooklyn, N.Y., Brooklyn Museum, 1940, no. 449 and p. 30.
Gift of Frank Jewett Mather, Jr. (48-1826)

The awkwardness of these sketches and the inscriptions suggest this is an early sheet, perhaps executed between 1842 and 1844, when Johnson returned to Augusta from Boston and began his career as an artist. Chandler was Johnson's mother's maiden name; perhaps Paul was an uncle. The disposition of the figures is also typical of the artist's early works. Johnson might have been sketching illustrations for a story.

53 *Dutch Peasant Girl*

Pencil, white highlights. 0.307 x 0.243 m.
Provenance: Frederick Keppel & Co., New York (label on back of former frame); Clifton R. Hall.
Bibliography: Baur, *An American Genre Painter,* no. 408; *The Laura P. Hall Memorial Collection of Prints and Drawings,* Princeton, Department of Art and Archaeology, Princeton University, 1947, no. 47 (listed).

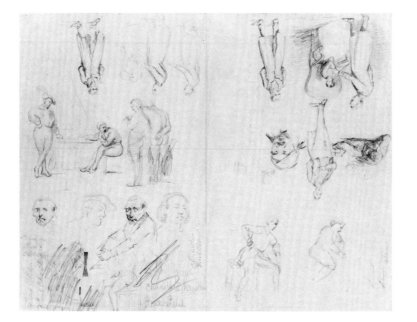

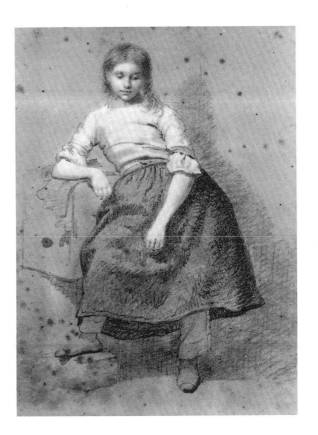

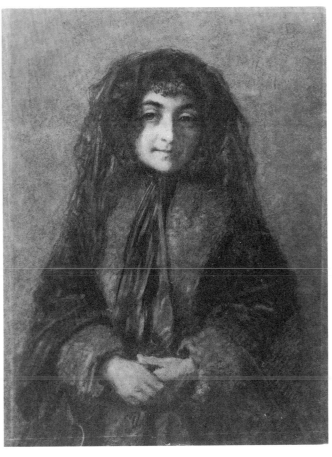

Laura P. Hall Memorial Collection, bequeathed by
Prof. Clifton R. Hall (46-271)

Probably made between 1851 and 1855, when Johnson was in The Hague, this drawing shows the
influence of Emanuel Leutze, with whom Johnson
studied in Düsseldorf in 1851.

54 *Portrait of Polly Gary*

Charcoal on tan paper; touches of white on nose.
 0.476 x 0.354 m.

Inscription: verso, in black chalk, *Polly Garey /
 The Hague*.
Bibliography: Baur, *An American Genre Painter*,
 no. 314; *Laura P. Hall Memorial Collection*, no.
 49 (listed).
Laura P. Hall Memorial Collection, bequeathed by
 Prof. Clifton R. Hall (46-273)

Portraits of the same sitter are in the Addison Gallery of American Art, Andover, Mass., and a private collection. This work typifies the artist's early
portrait phase, when he was strongly influenced by
European old masters.

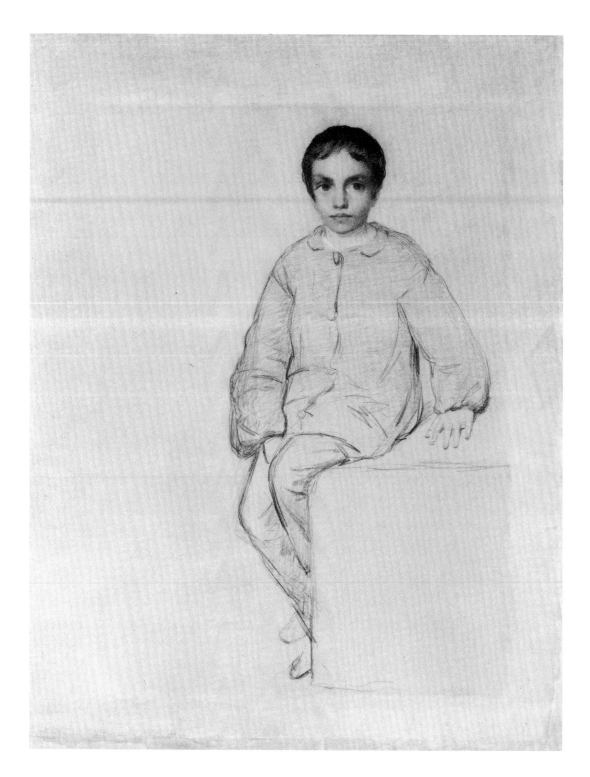

56

55 *Young Boy Seated*

Charcoal, white highlights, on tan paper. 0.715 x
0.536 m. (irregular).
Provenance: Albert Rosenthal (according to Baur);
Associated American Artists (label on back of for-
mer frame); Clifton R. Hall.
Exhibition and Bibliography: Baur, *An American
Genre Painter*, no. 388 and p. 34; *Laura P. Hall
Memorial Collection*, no. 48 (listed).
Laura P. Hall Memorial Collection, bequeathed by
Prof. Clifton R. Hall (46-272)

Like no. 54, this is an early portrait study, perhaps
from the late 1840s.

56 *Girl Seated on a Rock; Girl Standing by a Stream*
Verso: *Landscape*

Pencil. 0.227 x 0.304 m.
Gift of Frank Jewett Mather, Jr. (48-1787)

These sketches were probably used by Johnson in
his paintings of lovely ladies of the mid-1870s. Win-
slow Homer very much admired these paintings,
which were similar to ones he was producing at that
time. The landscape sketch on the verso demon-
strates an inability to represent distance and scale.

57 *Studies of Negroes*

Pencil. 0.227 x 0.304 m.
Gift of Frank Jewett Mather, Jr. (48-1788)

Around 1860 Johnson painted several genre studies
of home virtues, the most famous of which is his
Life in the South of 1859. These sketches un-
doubtedly date from this period, when he lived in
Washington, D.C. This and the drawing above (no.
56) are on the same kind and size of paper.

JOHN FREDERICK KENSETT

Cheshire, Conn. 1816–1872 New York City

58 *Tree*

Pencil on green paper. 0.237 x 0.355 m.
Exhibition: Brooklyn, N.Y., Brooklyn Museum,
　　25 November 1969–22 February 1970, *Drawings
　　of the Hudson River School 1825–1875* (by Jo Mil-
　　ler), no. 82 (illus.).
Gift of Frank Jewett Mather, Jr. (49-9)

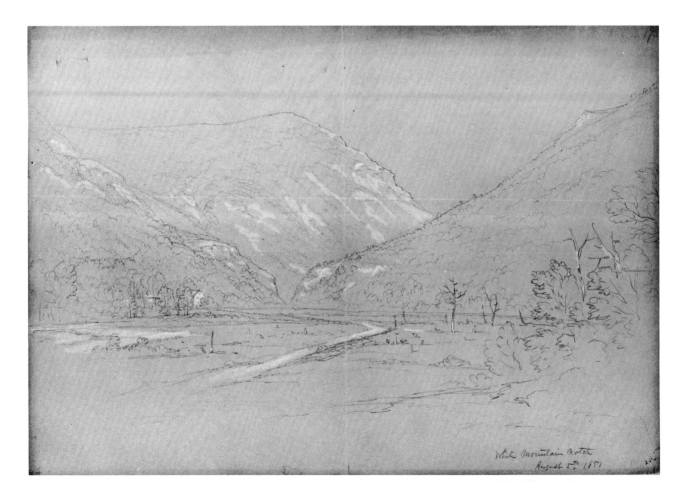

59 *White Mountain Notch*

Pencil, white highlights, on tan paper. 0.27 x
 0.378 m.
Inscription: lower right by the artist, title as
 given / *August 5th, 1851*.
Gift of Frank Jewett Mather, Jr. (49-8)

This sketch of Crawford Notch is from the period
when Kensett congregated with other artists in the
North Conway studio of Benjamin Champney and
went with them on walking tours in the mountains
of New Hampshire. It is interesting to compare this
drawing with Thomas Cole's rendition of the same
subject twelve years earlier (see Appendix, Cole
sketchbook, fol. 4).

JOHN LA FARGE

New York City 1835–1910 Providence, R.I.

The Art Museum is fortunate to have in its collection eighty-three drawings and watercolors by John La Farge. These range from small scraps of paper with unidentified scribblings to handsome watercolors, such as the *Halt of the Wise Men* included below. The collection has a few works from La Farge's student days in Europe in the 1850s, and many from his developed years. It represents the multiple facets of the artist's oeuvre, from book illustrations, to stage scenery designs, to studies for stained glass, to watercolors, to sketches for mural decorations. Many of these works are from two loose-leaf albums of miscellaneous drawings assembled after La Farge's death and sold at auction by his secretary, Miss Grace Barnes, executrix of his estate. Fourteen such albums were sold (American Art Galleries, New York, John La Farge Collection sale, 29–31 March 1911, nos. 850–64). The Museum's albums, which contained twenty-two and thirty-four drawings, respectively, have been disassembled; the items from them can be identified below by the accession numbers 46-65 and 46-66. Many of the sketches previously were mounted on sheets of manila board and identified, dated, and numbered in pencil by the artist, in an attempt at cataloguing them. According to Henry La Farge, the artist's grandson, he was encouraged to do this in his later years by Miss Barnes, when ill health and poor spirits kept him from his artistic endeavors. These notations have been very helpful in identifying subjects and dating works.

60 *Monk Praying*

Charcoal over pencil, white highlights, on brown paper. 0.212 x 0.099 m. (top rounded).
Inscription: lower right of mount in blue pencil by the artist, *1854.*

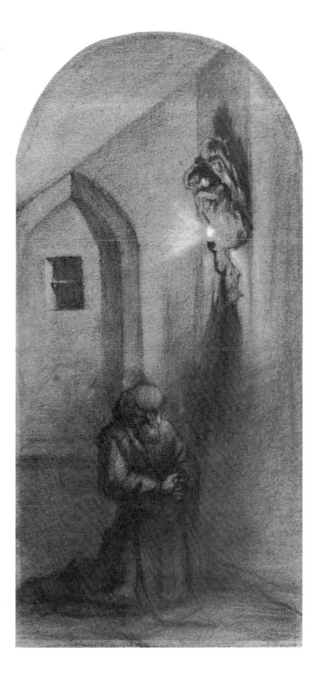

Provenance: American Art Galleries, New York, John La Farge Collection sale, 29–31 March 1911, no. 769; Doll & Richards, Boston (note on back of former frame).
Gift of Frank Jewett Mather, Jr., about 1946 (67-96)

La Farge is known to have been in Europe as a student in early 1856. This and two other similar drawings in the Museum's collection lend credence to the theory that he was there as early as 1854. The traditional style of this drawing may reflect the influence of Thomas Couture, with whom La Farge studied briefly in Paris.

61 *Portrait of Father Baker*

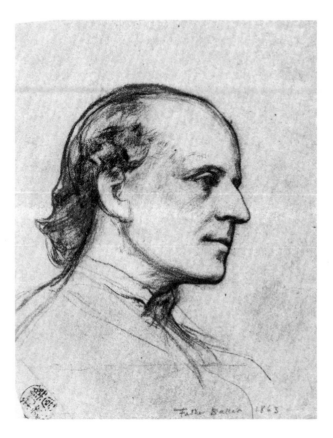

Soft pencil on thin paper. 0.138 x 0.102 m.
Inscriptions: lower right in pencil by the artist, *Father Baker 1863;* lower left, stamp of the artist (small version of Lugt 2976a).
Provenance: American Art Galleries, New York, John La Farge Collection sale, 29–31 March 1911, no. 798.
Exhibition: Princeton 1943, cover (illus.) and no. 13 (as *Father Bellar*).
Gift of Frank Jewett Mather, Jr. (43-31)

Incorrectly identified at Princeton until recently, the sitter is Francis Aloysius Baker (1820–1865), Princeton Class of 1839 and a convert to the Paulist order, for which La Farge, a Roman Catholic, felt a great affinity. The pose and facial expression in this drawing are similar to those in a portrait of Father Baker in *Catholic World,* 60, 1894, p. 201, which may be after La Farge, or perhaps both likenesses have a common origin in a photograph.

62 *Horse*

Soft pencil on rice paper. 0.109 x 0.145 m.

Inscription: verso of old mount in pencil by the artist, *Study—1866*.

Provenance: Leonard's Gallery, Boston, La Farge sale, 18–19 December 1879, no. 24.

Gift of Stuart P. Feld, Class of 1957, and Mrs. Feld (74-28)

This is the most developed of several horse sketches in the Princeton collection, all of which were executed during La Farge's Newport residency in the 1860s. In this period the artist made his studies in small sketchbooks with rice paper leaves. The Museum has a number of thin, small pages from such sketchbooks, which have varied studies, including birds, flowers, a turtle, landscapes, and early schemes for subject compositions.

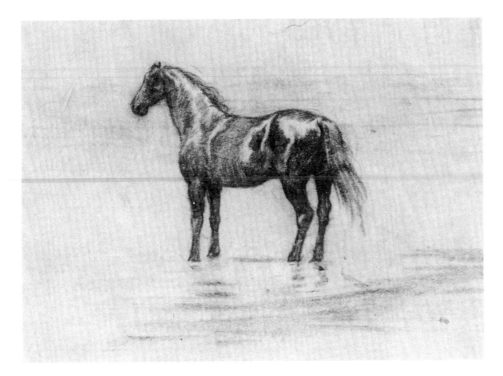

63 *Trionfo d'Amore*

Verso: *Tracing of Supporting Figure near Front of Litter*

Soft pencil over pencil on thin paper. Verso: pencil. 0.153 x 0.1 m.

Inscription: on mount in pencil by the artist, *Sketch for "Songs from Dramatists"* / *1866–7.*

Provenance: American Art Galleries, New York, John La Farge Collection sale, 29–31 March 1911, no. 728.

Gift of Frank Jewett Mather, Jr. (44-540)

64 *Trionfo d'Amore*

White ground, pencil, with gray, white, brown, and ivory(?) wash, on an uncut woodblock prepared for wood engraving. 0.15 x 0.092 m. In a heavy gold frame.

Inscriptions: across top, *TRIONFO D'AMORE;* verso, in various hands, *Triumph of Love* / *Mr. La Farge* / *La Farge* / *same size* / *on block 3 ¾ x 6* / *May 14 '79* / *Paid La Farge $25. for this block on a/c.*

Bibliography: Frank Jewett Mather, Jr., "American Paintings at Princeton University," *Record of The Art Museum, Princeton University,* 2, no. 2, 1943, p. 13 and fig. 17.

Gift of Frank Jewett Mather, Jr. (43-241)

La Farge began designing illustrations while he was convalescing from an illness in 1866, and continued into the 1870s. The inscription on the drawing (no. 63) indicates that it was originally intended as an illustration to precede the section "Love Songs" in A. S. Richardson's *Songs from the Old Dramatists,* published in 1873. Four other wood engravings after La Farge were used at the openings of other sections of this book. The *Trionfo d'Amore* was wood-engraved by Timothy Cole and published eight years later in *Scribner's Monthly,* 21, no. 4, February 1881, p. 505. Several uncut blocks by La Farge survive. His practice was to have the images transferred photographically to other blocks, which were then cut by professional wood engravers. In this way, his original paintings on the blocks could be preserved and the compositon could be reversed so it would appear in the same direction as the original when printed.

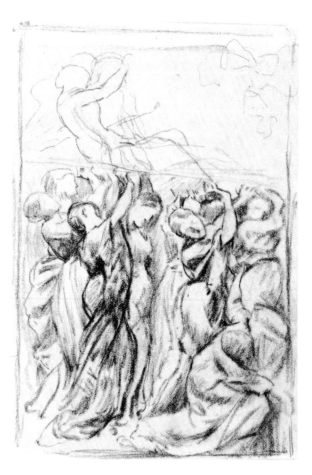

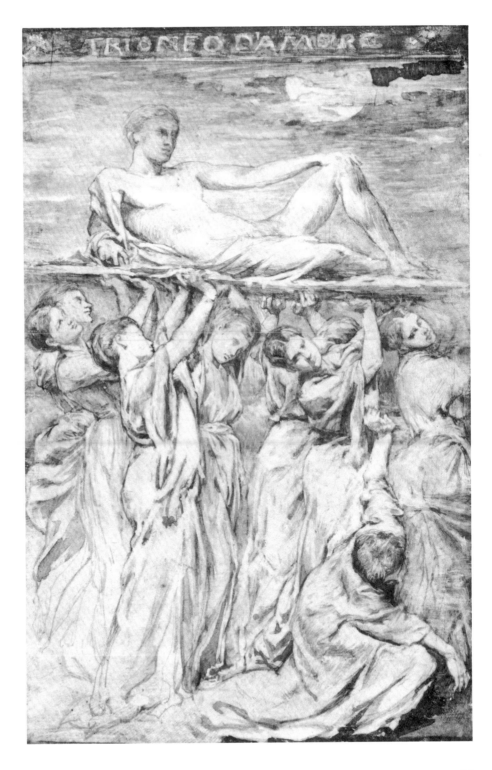

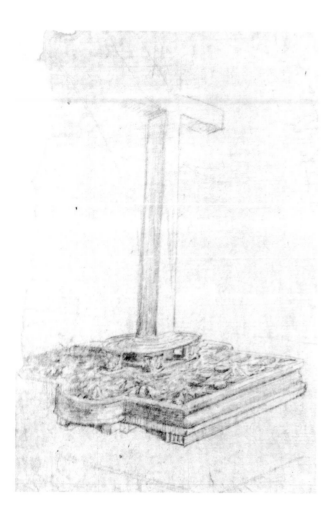

65 Cross on a Decorated Base: Study for King Monument

Soft pencil on thin, laid paper. 0.305 x 0.198 m. (irregular).
Gift of Frank Jewett Mather, Jr. (45-92)

66 Oak Leaves: Study for King Monument

Verso: *Sketch of Monument Base*

Soft pencil on heavy buff paper. 0.193 x 0.179 m.
Inscriptions: upper left, stamp of the artist (small version of Lugt 2976a); on mount in pencil by the artist, *Model for carving or modelling / for King Tomb / Date 1878 / #3075* [artist's number].
Provenance: detached from album (see discussion above).
Gift of Frank Jewett Mather, Jr. (46-65p)

The Edward King Monument in Newport, Rhode Island, was designed by La Farge, probably in 1876, and executed in 1878 in stone by the young sculptor Augustus St. Gaudens. The early scheme for the monument (no. 65) was somewhat altered in the final work. The detail sketch (no. 66) is for the carved oak leaf decoration. The Avery Library, Columbia University, has another oak leaf study by La Farge, probably from nature, and not yet enlarged for the sculptor as is this one.

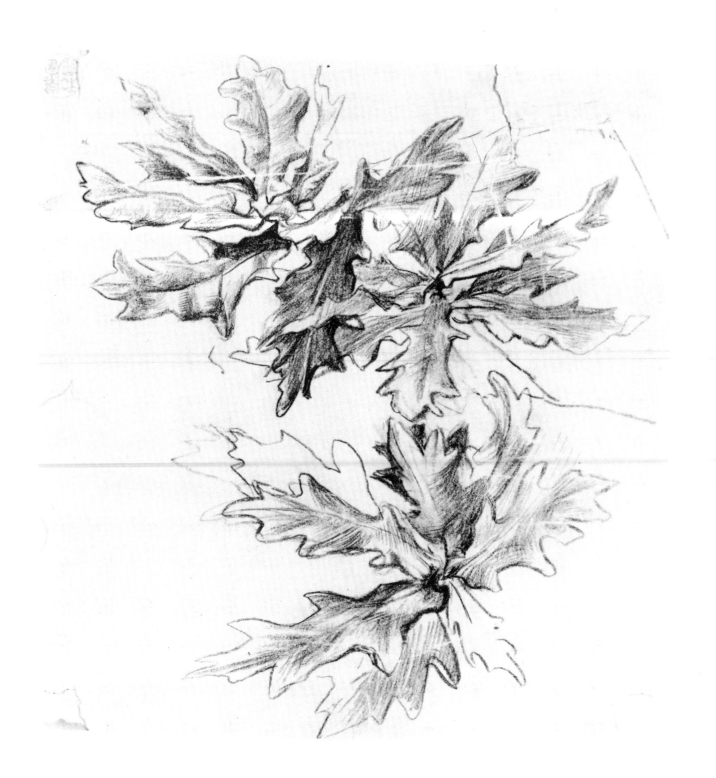

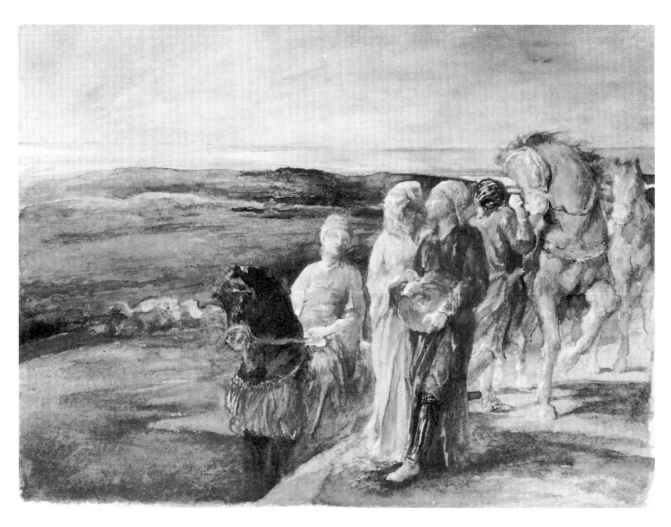

67 *Halt of the Wise Men*

Watercolor. 0.247 x 0.292 m.

Inscriptions: lower margin in blue pencil, *Name on back;* back of former frame on label in pencil, *Halt of the Wise / Men. / Study for picture same name / La Farge.*

Bibliography: Mather, "American Paintings at Princeton University," p. 12 and fig. 16.

Gift of Frank Jewett Mather, Jr. (43-198)

Contrary to the inscription on the back of the frame of this picture, it does not seem to be a study for La Farge's oil painting (Museum of Fine Arts, Boston), but, rather, an independent version of the same subject. Both probably date from 1868. A wood engraving after this design, executed by a Mr. Whitney, was published in *Riverside Magazine for Young People,* 2, 1868, opp. p. 529, and later in *The Bodleys Telling Stories,* 1878, p. 229. Henry La Farge, the artist's grandson, has the uncut block of this subject with an original drawing on it.

68 *First Sketch for Decoration over Great Arch of Tower, Trinity Church, Boston*

Charcoal pencil over pencil. 0.155 x 0.293 m.

Inscriptions: across center in pencil by the artist, *bracket suggested by Mr. Cottier / not accepted as not in the style;* on separate cutout (probably from an old mount) in pen by the artist, title as given, *1876.*

Provenance: detached from album (see discussion above).

Gift of Frank Jewett Mather, Jr. (46-65m)

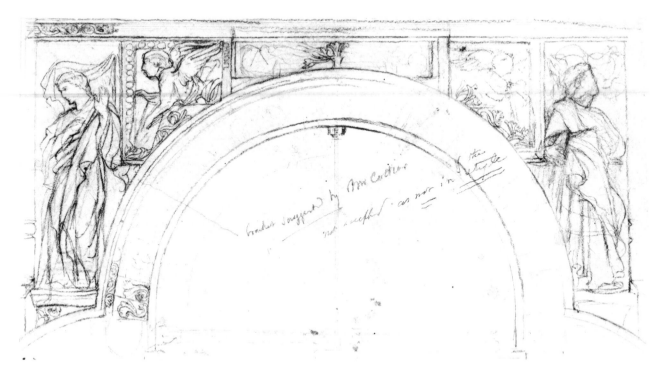

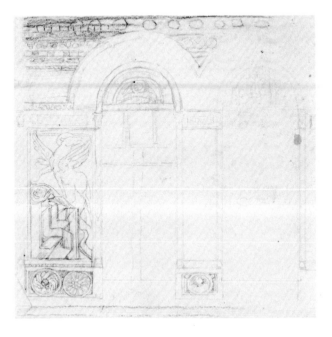

69 *Study for Decoration of North Wall of Tower, Trinity Church, Boston*

Pencil, charcoal pencil. 0.178 x 0.182 m.
Provenance: detached from album (see discussion above).
Gift of Frank Jewett Mather, Jr. (46-65*l*)

70 *Christ: Study for "Christ and Nicodemus," Trinity Church, Boston*
Verso: *Studies of a Base and Capital*

Black crayon on blue gray paper. Verso: pencil with brown wash additions. 0.27 x 0.172 m.
Inscriptions: lower left by the artist, *Study for figure of;* below this in pencil, X^t *of Trinity Nave. 1877;* lower right, stamp of the artist (small version of Lugt 2976a).
Provenance: American Art Galleries, New York, John La Farge Collection sale, 29–31 March 1911, no. 793.
Gift of Frank Jewett Mather, Jr. (46-98)

The first large mural project in America was for Trinity Church in Boston. La Farge was engaged in September 1876 to design decorations for the interior surfaces of the church, under the close scrutiny of the architect, H. H. Richardson. Daniel Cottier, a New York art dealer and decorator, was hired as painting contractor to replace the painting firm of Hill and Treharne, which withdrew early in the project. Cottier's workmen were responsible for the interior non-decorative painting and may have contributed to the geometric ornamentation. Construction work was still in progress as the mural paintings were being executed by a corps of ten to fifteen

artists under the supervision of La Farge. There was a frantic urgency to finish; sometimes drawings made by La Farge one evening were realized the very next day. It is no wonder that few of the sketches have survived. Two of those above (nos. 68 and 69) are early sketches for decorations that were changed considerably in the finished conception. The first, for the lower south wall of the tower, flanking the arch, depicts Isaiah and Jeremiah with angels and decorations between them. It is not known which assistants painted these. The decoration of the upper north wall of the tower features two of the Evangelist symbols flanking three windows, with Old Testament narratives in their lunettes. The Ox of Saint Luke, which was painted by Frank Millet, and two of the windows are indicated in the second drawing.

The *Visit of Christ and Nicodemus* (John 3:1–21) was executed by La Farge on the south wall of the nave, balanced by *Christ and the Woman of Samaria* on the north. As the inscription on no. 70 indicates, the composition was conceived in 1877, but it was not painted by La Farge in Trinity until 1878, after he had done the Saint Thomas murals in New York, from which he gained valuable experience. A watercolor version by La Farge of the same subject, which shows Christ and Nicodemus seated partially turned toward each other, was in Kennedy Galleries, New York, in 1974. An oil on canvas is in the National Collection of Fine Arts, Washington, D.C., and the subject was repeated much later in stained glass for a window in the Church of the Ascension, New York. The studies on the verso of Princeton's drawing are possibly for the King Monument in Newport. [Much of this information is from H. B. Weinberg, "John La Farge and the Decoration of Trinity Church," *Journal of the Society of Architectural Historians,* 33, no. 4, December 1974, pp. 323–53.]

72

71 *Study for "The Three Maries," Saint Thomas' Church, New York*

Pencil on thin paper. Squared for transfer. 0.322 x 0.259 m.

Inscriptions: lower left in pencil by the artist, *Newport / 1877;* squaring-off lines numbered on four sides; upper right, stamp of the artist (small version of Lugt 2976a).

Exhibition: Princeton 1943, no. 12.

Bibliography: Charles E. Slatkin and Regina Shoolman, *Treasury of American Drawings,* New York, Oxford University Press, 1947, no. 73 (illus.); E. P. Richardson, "What Is the American Line?" *Art News,* 47, no. 3, May 1948, p. 18 (illus.) (review of exhibition, based on Slatkin / Shoolman book, at Detroit Institute of Arts, spring 1948, in which this drawing was shown).

Gift of Frank Jewett Mather, Jr. (43-32)

Immediately after his tower decorations for Trinity Church, in the summer of 1877, La Farge was commissioned to paint two scenes from the Resurrection for the chancel of Saint Thomas' Church, New York, which was completely destroyed by fire in 1905. On the left side was the *Noli me Tangere* separated, by a reredos sculpted by Augustus St. Gaudens, from *The Visit of the Three Maries to the Tomb,* for which the above drawing is a study. The scene portrays the three Maries at the right confronted by two men clothed in drapery who point to the left toward the tomb. H. B. Weinberg ("La Farge's Eclectic Idealism in Three New York City Churches," *Winterthur Portfolio,* 10, 1975, pp. 208–9 and fig. 8) gives La Farge's source for the figures of *The Three Maries* as an Early Christian ivory relief, now in the Bayerisches Nationalmuseum, Munich. A watercolor of the same subject is in the collection of Henry La Farge, the artist's grandson.

72 *The Sense of Smell*

Watercolor. 0.226 x 0.153 m.
Inscription: verso, in pencil, *Wm J McGuire*[?] (a former owner?).
Provenance: Louis Tiffany sale (undocumented note in Museum's records).
Gift of Frank Jewett Mather, Jr. (46-95)

The Museum of Fine Arts, Boston, has a version of

this subject in oil on canvas called *Nude* or *Ceres*. According to Helene Barbara Weinberg ("The Decorative Work of John La Farge," Ph.D. dissertation, Columbia University, 1972) the study was for one of a series of large watercolors depicting personifications of the senses to decorate curved T-shaped pendentives in the vaulted ceiling of the so-called Watercolor Room in the Cornelius Vanderbilt house, New York, circa 1882. There is a general confusion in the literature between this series representing the senses and designs by La Farge for four relief panels representing Ceres, Pomona, Bacchus, and Vertumnus, which were carved in wood by Augustus St. Gaudens for the dining room of the Vanderbilt house. Presumably the two sets of designs were different. The Cornelius Vanderbilt house was demolished in 1927. The fireplace was given to the Metropolitan Museum of Art, New York; it is not known if the watercolors were removed before the demolition.

73 *South Sea Dance, Samoa*

Watercolor. 0.265 x 0.391 m.
Inscriptions: lower left in ink by the artist, *La Farge;* lower right, *1890 / Samoa.*
Provenance: Durand-Ruel (according to Henry La Farge).
Exhibition: Philadelphia, Art Club of Philadelphia (undocumented note in Museum's records).
Gift of Frank Jewett Mather, Jr. (48-1798)

This is one of many splendid watercolors resulting from a trip to the South Seas that La Farge made with Henry Adams in 1890–91, the second of such voyages, the first being to Japan in 1886. A similar version of this subject by La Farge was formerly in the collection of the Whitney Museum of American Art, New York.

74 *Fortune: Study for Window, Frick Building, Pittsburgh*

Pencil on thin paper. 0.278 x 0.201 m.
Inscriptions: lower right by the artist, *JLF May 11 1901;* lower right, stamp of the artist (small version of Lugt 2976a).
Gift of Frank Jewett Mather, Jr. (43-33)

Two other studies by La Farge for the same window exist. In one of these, a watercolor, Fortune is

seated on the wheel, which is turned three-quarters toward the viewer. The second study, closer to the final representation in stained glass, is more like this design, except that Fortune is less precariously balanced, her arms are more relaxed, and she has long flowing hair. Perhaps La Farge's greatest achievements were the stained-glass windows he designed, which number over one thousand. He invented a handsome and peculiarly American opalescent glass, which he used extensively.

75 *Draped Female Figure, Looking Up*

Pencil. 0.35 x 0.275 m.
Inscription: lower left, stamp of the artist (small version of Lugt 2976a).
Gift of Frank Jewett Mather, Jr. (45-84)

A watercolor by La Farge of the same figure, dated 1903, is in the collection of Berea College in Kentucky. The figure was used by the artist in 1887 or 1888 in *The Ascension* (chancel, Church of the Ascension, New York), a large arch-shaped painting depicting the ascending Christ in the center surrounded by tiers of angels, with a group of onlookers standing on the ground below. This study is for the angel writing on a tablet at the lower left. A wash drawing for the mural is in the collection of Mount Saint Mary's College, Emmitsburg, Md., La Farge's alma mater. The angel is in a similar position, but the features have not yet been individualized by study from a model as they appear in the Princeton drawing and in the finished mural. The subject was repeated, without the onlookers, in the Craeger Memorial Window, Second Presbyterian Church, Chicago. A watercolor study (without this figure) for the Craeger window was in the Macbeth Gallery, New York, in 1915.

76 *Standing Woman*

Watercolor over pencil. 0.307 x 0.228 m.
Inscription: lower center in pencil, *Unfinished sketch by / John LaFarge / (From the Executrix, Miss Grace E. Barnes.)*.
Gift of Frank Jewett Mather, Jr. (43-73)

We have been unable to find this figure in any finished works by the artist. This watercolor undoubtedly dates around 1900.

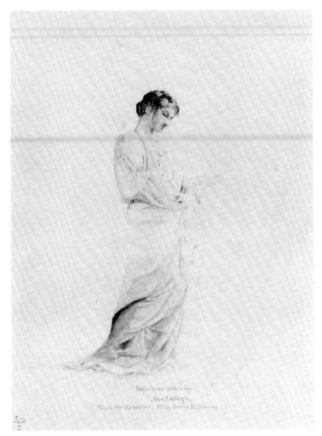

77 *Poets and Muses: Study for Stage Scenery*

Watercolor over pencil. 0.16 x 0.238 m.
Inscription: verso of former mount, stamp of the artist *(John La Farge / 86 East 17th St. Union Square / New York)*.
Exhibition: Princeton 1943, no. 11 (as *The Crown of Laurel*).
Gift of Frank Jewett Mather, Jr. (43-75)

This watercolor was formerly on a mount, on the verso of which was attached a La Farge study for a stained-glass window (a decorative panel with floral motifs). A second design for stage scenery in the Princeton collection (acc. no. 43-74) is inscribed on the verso by the artist: *Theatre Curtain No. 94*. The high number would indicate that stage design was not a small part of the artist's production. The subject of the scene has not been identified; it has been referred to as *Parnassus*. The lower right corner is unfinished.

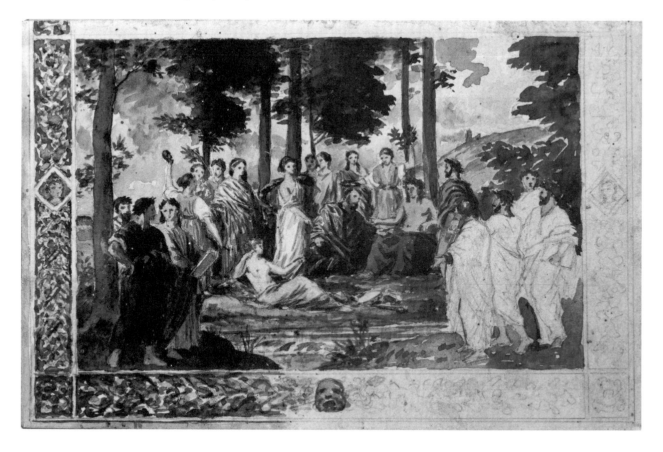

EMANUEL LEUTZE

Gmünd, Württemberg, Germany 1816–1868 Washington, D.C.

78 *Peasant Girl Carrying Faggots*

Pencil, brown pastel, stumped(?), touches of
white wash, on brown paper. 0.264 x 0.244 m.
(irregular).
Gift of Frank Jewett Mather, Jr. (44-537)

This is undoubtedly an early work by the historical
painter who is most famous for his *Washington
Crossing the Delaware* and for his role as a link
between American artists and the fashionable
Düsseldorf school of painting. Leutze has been ac-
cused of making his figures, even those pictured at
the most important of events, all look remarkably
like German peasants, as does the girl in this draw-
ing.

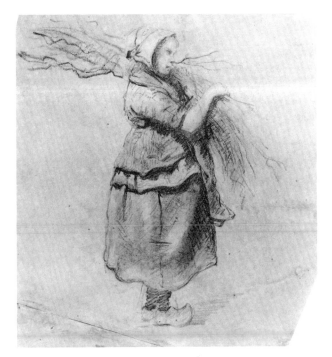

WILL HICOK LOW

Albany, N.Y. 1853–1932 New York City

79 *Tailpiece: Dante*

Pen and black ink, gray and brown wash, white
 gouache, over pencil. 0.11 x 0.241 m.
Inscriptions: upper left in pen and black ink by the
 artist, *WHL;* lower margin in pencil, title as
 given / *1 col.*
Gift of Stuart P. Feld, Class of 1957, and Mrs. Feld
 (70-135)

This particular subject has not been located among
Low's published illustrations; the *1 col* designation
indicates that this drawing has probably been in a
layout man's hands. Low was one of many painters,
including La Farge, Homer, and Cox, who regularly
submitted paintings and drawings to be wood-en-
graved as illustrations in books and periodicals.

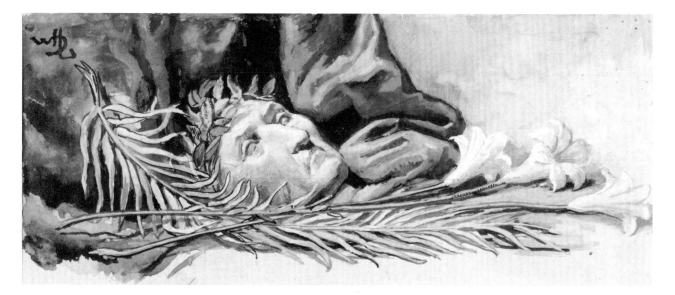

FREDERICK MacMONNIES

Brooklyn, N.Y. 1863–1937 New York City

80 *Standing Nude Youth with Scarf*

Charcoal. Watermarks: *PDC* and *P L BAS*. 0.59 x
0.302 m.

Inscription: lower right in pencil by the artist, *Fre-
derick MacMonnies / Munich 84.*

Exhibition: Binghamton, N.Y., State University of
New York, University Art Gallery, New York,
Finch College Museum of Art, and William-
stown, Mass., Sterling and Francine Clark Art
Institute, 1974, *Strictly Academic,* no. 52 (illus.).

Gift of Mrs. Henry White Cannon, Sr. (39-120)

81 *Standing Male Nude*

Charcoal. Watermarks: *AL* within a wreath and
P L BAS. 0.616 x 0.358 m.
Inscription: lower right in pencil by the artist, *Mac-
Monnies / 1885*.
Exhibition: Binghamton 1974, no. 53 (illus.).
Gift of Mrs. Henry White Cannon, Sr. (39-121)

82 *Study of a Bearded Old Man*

Charcoal, stumped. Watermarks: *AGM* and *Glas-
lan*. 0.453 x 0.57 m.
Inscription: lower right by the artist, *Frederick
MacMonnies / Munich 84*.
Gift of Mrs. Henry White Cannon, Sr. (39-122)

MacMonnies executed these three student works
from life in Munich, where he went in 1884 to es-
cape a cholera epidemic in Paris. The year 1887
found him back in Paris, where he established a
studio he was to maintain for over twenty-five
years. Prof. Robert J. Clark of Princeton knows of a
photograph of the artist taken in his Paris studio,
which shows the bust-length study of an old man
(no. 82) hanging on the wall, indicating, perhaps,
the artist's fondness for this drawing. These early
studies predict, in their feeling for mass and vol-
ume, the artist's later concentration on sculpture.
The lower half of the *Standing Male Nude* is hastily
drawn and unnaturally elongated.

83

HOMER DODGE MARTIN

Albany, N.Y. 1836–1897 Saint Paul, Minn.

The Art Museum has a sketchbook and twenty-six drawings by Homer Martin in its collection, all except one of which was given by Frank Jewett Mather, Jr., who in turn acquired most of his from the estate of James Stillman, Sr., a banker, friend of the artist, and fellow member of the Century Association. Thirteen of the drawings are in the tight, dry, meticulous style of Martin's early period (1858–1861), while others are in the broader, more affirmative technique that he adopted later. Professor Mather dates his freer style 1875 and 1876, when Martin first directly encountered European artists; the present writer speculates that the transition may have occurred gradually after his move to New York in the winter of 1862–63 and his resulting association with Homer and La Farge, fellow tenants at the Tenth Street Studio Building. Martin's drawings are for the most part not sketches, but carefully worked out compositional studies for later paintings; he relied on memory for details and color, to the end that his oils frequently lacked definition. His later drawings are more often wash than pencil. After his second European sojourn, between 1882 and 1886, he was in failing health and eyesight and executed very few drawings. (For Martin's sketchbook, see the Appendix.)

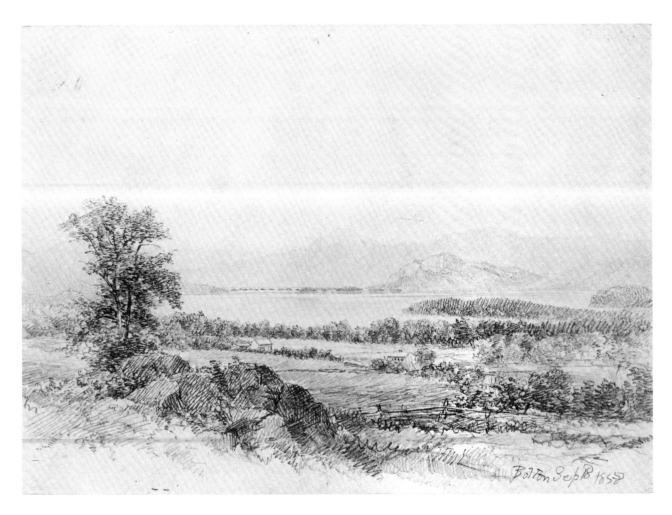

83 *Trees and Pool*

Pencil over a textured surface. 0.217 x 0.285 m.
Inscription: lower right by the artist, *July 30.5[?]3.*
Provenance: estate of James Stillman, Sr.
Gift of Frank Jewett Mather, Jr. (42-187)

Seemingly a very early work, this reminds us of
drawings by other artists working in Albany in the
1850s.

84 *Lake George from Bolton*

Pencil. 0.177 x 0.242 m.
Inscription: lower right by the artist, *Bolton Sep 18
1858.*
Provenance: estate of James Stillman, Sr.
Gift of Frank Jewett Mather, Jr. (42-176)

This is one of six early drawings in the Museum's
collection that were sketched by Martin on a trip to
the Lake George area, August to October 1858. A
painting of a similar view is illustrated in Dana H.
Carroll, *Fifty-Eight Paintings by Homer D. Martin,*
New York, 1913, no. 2.

85 *Bridge at Leeds, Greene County, N.Y.*

86 *Waterfall*

Pencil on tan paper. 0.192 x 0.273 m.
Inscription: lower right by the artist, *Leeds. Green Co. Aug 2* [crossed out] *Aug 4* [above] *1859.*
Provenance: estate of James Stillman, Sr.
Exhibition: Princeton 1943, no. 16 and fig. 4 (as *The Bridge*).
Gift of Frank Jewett Mather, Jr. (42-185)

There is another drawing by Martin (acc. no. 42-182) in the Princeton collection, probably of the same bridge.

Pencil. 0.253 x 0.355 m.
Provenance: estate of James Stillman, Sr.
Exhibition: Princeton 1943, no. 15.
Gift of Frank Jewett Mather, Jr. (42-168)

An oil painting by Martin entitled *The Old Mill* and dated 1860 (see Frank Jewett Mather, Jr., *Homer Martin: Poet in Landscape,* New York, 1912, opp. p. 16) possibly depicts part of the waterfall shown in this drawing.

87 *Rocky Outcrop*

Pencil. 0.213 x 0.299 m.
Inscription: lower right by the artist superimposed
 over drawing, *July 3d 1861.*
Provenance: estate of James Stillman, Sr.
Gift of Frank Jewett Mather, Jr. (42-183)

This drawing probably was made near Twin Lakes,
Conn., where the Martins spent the first month of
their married life.

88 *Landscape: Fort Ann*

Pencil. 0.214 x 0.299 m.
Inscription: lower right by the artist, *Fort Ann
 Aug 27. 61.*
Provenance: estate of James Stillman, Sr.
Gift of Frank Jewett Mather, Jr. (42-170)

The Martins stayed at Fort Ann, New York, at the
home of Thaddeus Dewey for the first year after
their marriage on 25 June 1861.

89 *Storm King on the Hudson*

Pencil. 0.254 x 0.353 m.
Provenance: estate of James Stillman, Sr.
Gift of Frank Jewett Mather, Jr. (42-178)

This drawing closely corresponds, even to the
fallen tree in the foreground, to an oil painting in the
Albany Institute of History and Art.

90 *Landscape: Middle Forge*

Pencil on blue paper. 0.185 x 0.275 m.(irregular).
Inscription: lower left by the artist, *Middle Forge*
 (superimposed over illegible erasure).
Provenance: estate of James Stillman, Sr.
Gift of Frank Jewett Mather, Jr. (42-179)

Middle Forge

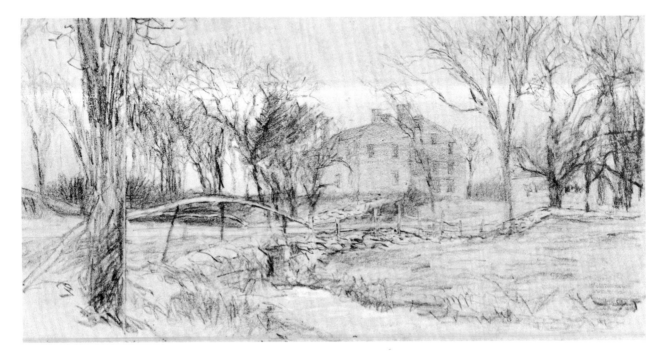

91 *Buttermilk Falls Carry on Raquette River*

Pencil on buff paper. 0.292 x 0.183 m.(irregular).
Inscription: lower right by the artist, *Buttermilk Falls Carry / on Rquette River / Sep. 69.*
Gift of Macbeth Galleries, New York (46-410)

92 *Large House, Brook, and Bridge*

Soft pencil, white highlights, on greenish gray paper; on a sketchbook leaf with vertical fold and thread holes near left side. 0.165 x 0.315 m.
Provenance: estate of James Stillman, Sr.
Gift of Frank Jewett Mather, Jr. (42-169)

In the three drawings above we can see a loosening of style and the use of softer drawing media.

93 *Sketch of Whistler*

Black crayon(?) on olive gray paper. 0.18 x 0.093 m.

Inscriptions: bottom in black crayon, inverted, *Hyans*[?] *W. of Wells*[?] *St;* verso, in pencil, *by Homer D. Martin / from Homer D. Martin / Collection of / Sketches / from Mr. & Mrs. Martin / purchased*[?] *from Wm Macbeth / inc. / by Albert Rosenthal / Presented by him to / Alexander Lieberman / 1.30.1922.*

Provenance: see inscription on verso; purchased at auction, New York, 1944.

Bibliography: Frank Jewett Mather, Jr., "A Sketchbook of 1875 and 1876 by Homer D. Martin," *Record of The Art Museum, Princeton University,* 4, no. 1, 1945, p. 8 and fig. 8.

Gift of Frank Jewett Mather, Jr. (44-245)

This slender, abraded sketch has been included here more for documentary than artistic purposes. Martin met Whistler in London in 1875 and they became good friends. Whistler is said to have given the following introduction: "Gentlemen, this is Homer Martin. He doesn't look as if he were, but he is" (Mather, p. 7).

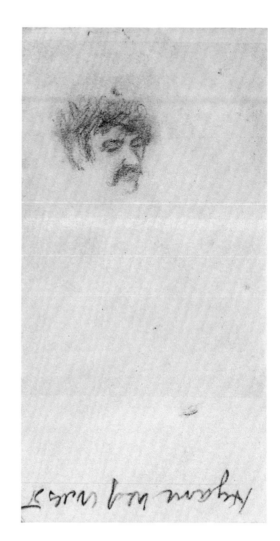

94 *Forest Scene with Washerwoman*

Brush and gray wash. 0.3 x 0.18 m.
Inscription: lower right in pen and black ink by the artist, *Homer Martin*.
Gift of Frank Jewett Mather, Jr. (46-64)

95 *Winter in Normandy*

Watercolor. 0.358 x 0.255 m.
Inscription: lower left by the artist, *H.D.Martin / April 14*[?] / *86*[?].
Provenance: William Crary Brownell (according to Carroll).
Bibliography: Dana H. Carroll, *Fifty-Eight Paintings by Homer D. Martin*, New York, 1913, no. 7 and p. 27 (illus.).
Gift of Frank Jewett Mather, Jr. (51-87)

The two preceding drawings date between 1882 and 1886, Martin's second European sojourn. Mrs. Martin writes (in *Homer Martin: A Reminiscence*, New York, W. Macbeth, 1904, p. 27), ''I look back on the time we spent in Villerville as the most tranquil and satisfactory of our life together.''

WILLIAM RICKARBY MILLER

Staindrop, near Darlington, England 1818–1893 New York City

96 *Canoes and Rowboat*

Pencil. 0.381 x 0.277 m.

Inscriptions: center left by the artist, *June 4th;* lower left by the artist, *Fort Williams / July 26th, 1846.*

Provenance: Harry Shaw Newman Gallery (Old Print Shop), New York.

Museum purchase (49-249)

Miller could well have traveled to Fort William, Ontario, on Lake Superior, from his home in Buffalo where he lived after his immigration to this country in 1844 or 1845, until 1847 or 1848, when he moved to New York.

CHARLES HERBERT MOORE

New York City 1840–1930 Hartfield, Hampshire, England

The Museum has thirteen watercolors and three drawings by Charles Herbert Moore, from which the following have been selected. Moore's early career as an artist was virtually halted in 1871, when he moved to Cambridge, Mass., to join the Harvard University faculty. He later became Director of the Fogg Art Museum. After his move to Harvard, he produced only landscape watercolors and a few drawings as a leisure pastime on vacations.

97 *Pine Tree*

Verso: *Landscape Sketch*

Pen and black ink, pencil, on heavy tan paper. 0.637 x 0.507 m.
Inscription: lower right in pencil by the artist, *Catskill / 1868.*
Provenance: the artist's family.

The Valley of the Catskill from Jefferson Hill. C.H.Moore. 1869.

Exhibition: Washington, D.C., National Collection of Fine Arts, 30 April–7 November 1976, *America as Art,* no. 144.

Bibliography: Frank Jewett Mather, Jr., *Charles Herbert Moore: Landscape Painter,* Princeton, Princeton University Press, 1957, p. 31 and fig. 16; Joshua C. Taylor, *America as Art,* Washington, D.C., Smithsonian Institution Press, 1976, p. 124 (illus.).

Gift of Miss Elizabeth Huntington Moore, the artist's daughter (51-89)

Moore's meticulous attention to detail can be seen in this unfinished drawing.

98 *The Valley of the Catskill from Jefferson Hill*

Pen and black ink, gray wash. 0.171 x 0.245 m.

Inscriptions: lower margin, title as given / *C. H. Moore. 1869;* verso, in pencil by the artist, practice monogram *CM* and long inscription, partially cut off, indicating his intention to make a series of etchings illustrating the Hudson River.

Provenance: the artist's family.

Bibliography: Mather, *Charles Herbert Moore,* pp. 25, 34–35, 39, and fig. 13.

Presented by Mrs. Frank Jewett Mather, Jr., as the

gift of Miss Elizabeth Huntington Moore, the artist's daughter (55-76)

The Vassar College Art Gallery has an oil painting by Moore of the same subject, dated 1861. This is a later pen drawing, preparatory to an etching.

99 *Mount Washington*

Watercolor over pencil. 0.303 x 0.457 m.
Provenance: the artist's family.

Exhibition: Boston, Everett & Williams, early 1870s (pencil note on verso).
Bibliography: Mather, *Charles Herbert Moore*, title page (illus.) and pp. 39–40.
Gift of Miss Elizabeth Huntington Moore, the artist's daughter (51-88)

Mather discusses how unfinished this drawing is and dates it 1870 or a little later. The Moores spent the summers of 1869 and 1870 in the White Mountains of New Hampshire.

100 *Sawmill at West Boxford*

Watercolor. 0.302 x 0.457 m.
Provenance: the artist's family.
Exhibition: Washington 1976, no. 145.
Bibliography: Mather, *Charles Herbert Moore*,
 pp. 46–47, 71, and fig. 28; Taylor, *America as Art*,
 p. 125 (illus.).
Presented by Mrs. Frank Jewett Mather, Jr., as the

gift of Miss Elizabeth Huntington Moore, the
artist's daughter (55-70)

The Moores had a summer home in West Boxford,
Mass., from 1874 to 1909. Mather dates this draw-
ing 1874, before the artist's European trip and sub-
sequent involvement in teaching. This was one of
the works Moore selected to take with him on his
final move to England in 1909.

101 *Water Mill, Simplon Village*

Watercolor over pencil. Watermark: *J. Whatman.*
 0.284 x 0.394 m.
Inscription: verso, in pen and ink, *1877. E.H.M.*
 (donor's initials).
Provenance: the artist's family.
Bibliography: Mather, *Charles Herbert Moore,*
 p. 51 and fig. 33.
Presented by Mrs. Frank Jewett Mather, Jr., as the
 gift of Miss Elizabeth Huntington Moore, the
 artist's daughter (55-71)

102 *Simplon Village*

Watercolor over pencil. Watermark: *WHATMAN 1867*. 0.282 x 0.394 m.

Inscription: verso, in pen and ink, *1877. E.H.M.*

Provenance: the artist's family.

Bibliography: Mather, *Charles Herbert Moore*, pp. 51–52 and fig. 32.

Presented by Mrs. Frank Jewett Mather, Jr., as the gift of Miss Elizabeth Huntington Moore, the artist's daughter (55-73)

103 *Simplon Village*

Watercolor over pencil. 0.29 x 0.388 m.

Inscriptions: lower center in pencil, *goats on the green;* verso, in pen and ink, *1877. E.H.M.*

Provenance: the artist's family.

Presented by Mrs. Frank Jewett Mather, Jr., as the gift of Miss Elizabeth Huntington Moore, the artist's daughter (55-72)

104 *Storm Clouds over Simplon Village*

Watercolor over pencil. Watermark: *WHATMAN 1877.* 0.286 x 0.392 m.

Inscription: lower right in pen and ink by the artist, *C.H.M. / 1881.* (date in darker ink).

Provenance: the artist's family.

Bibliography: Mather, *Charles Herbert Moore,*
 p. 51 and fig. 31.
Gift of Frank Jewett Mather, Jr. (47-189)

The preceding are four of six similar watercolors
(five in this Museum; one in the Fogg Art Museum)
begun in Simplon Village, Switzerland, in the sum-
mer of 1877, where Moore vacationed and met and
formed a friendship with John Ruskin. *Simplon Vil-
lage* (no. 102) is unfinished. *Storm Clouds over Sim-
plon Village* (no. 104) was undoubtedly begun in
1877 and finished, initialled, and dated by Moore
four years later, in 1881. The 1877 watermark and
lack of freshness lend credence to this speculation.

THOMAS MORAN

Bolton, Lancashire, England 1837–1926 Santa Barbara, Calif.

105 *Venice: The Lagoon Looking toward Santa Maria della Salute*

Watercolor over pencil. Borderlines in pencil. 0.273 x 0.411 m.

Inscriptions: lower right in pen and ink by the artist, *TMORAN* [T and M superimposed] / *1894.;* verso of former mount in pencil, *Santa Maria della Salute, Venice. Moran. 37 West 22nd.*

Provenance: George Willis Pack, Cleveland (the donor's grandfather).

Exhibition: Berkeley, Calif., University Art Museum, 30 September–23 November 1975, *J. M. W. Turner: Works on Paper from American Collections* (by Joseph R. Goldyne), no. 76 (illus.).

Gift of Mrs. Philip T. White (69-370)

Moran's two visits to Venice, in 1886 and 1890, inspired many later oils and watercolors, of which this is a good example.

106 *Landscape*
Verso: *Anatomical Sketch*

Pencil, brush and white wash, on blue paper. Convergence lines superimposed in pencil. 0.25 x 0.323 m.
Inscription: lower left in pencil, *After. Morans Turner.*
Gift of Frank Jewett Mather, Jr. (48-1835)

If this drawing is indeed by Moran, it undoubtedly is an early work which copies or imitates a Turner painting or drawing of the early 1830s. Moran was an ardent admirer of Turner's work, to which he was introduced through the *Liber Studiorum* by his teacher James Hamilton. He later studied closely Turner watercolors and paintings on his first trip to England in 1861–62.

WILLIAM SIDNEY MOUNT

Setauket, Long Island, N.Y. 1807–1868 Setauket, Long Island, N.Y.

107 *Waiting for the Tide: Study for Composition and Detail of Figure*

Pencil. 0.24 x 0.15 m.

Inscriptions: across center by the artist (?), *waiting for the tide* [partially erased]; lower left, *Fancy Sketches*.

Provenance: purchased from Victor D. Spark, New York.

Museum purchase (45-67)

A painting by Mount with the same title was in his executors' sale, Somerville Art Gallery, New York, 10–11 April 1871. The lower inscription, if by the artist, might indicate that he was planning some kind of publication of his sketches, with this image on the title page.

108 *Reading*

Pencil. 0.095 x 0.09 m.

Inscription: lower center by the artist, title as given.

Provenance: purchased from Victor D. Spark, New York.

Museum purchase (45-66)

109 *Scene with a Dancing Figure*

Pencil. 0.095 x 0.115 m.

Provenance: purchased from Victor D. Spark, New York.

Museum purchase (45-65)

Mount filled many large pages with small composition sketches, usually within their own borders and often labeled; the two sketches above have been cut from such typical sheets. The first is perhaps a study for *"The Herald" in the Country*, 1853. A note on the mount indicates that the second is a study for *Dance of the Haymakers*. However, it is more likely related to *The Breakdown* of 1835 (Art Institute of Chicago), a barroom scene in which several figures are watching another, who is engaged in the dance indicated by the title of the painting.

JOHN NEAGLE

Boston 1796–1865 Philadelphia

110 *Heads of Two Children*

Black chalk, white highlights, over pencil, on pur-
plish brown paper. 0.385 x 0.333 m.
Inscriptions: lower right in pen and brown ink by
the artist, *John Neagle / Phila. 1831;* upper cen-
ter in pencil, *Brown;* upper right, *yellow-brown;*
left center, *5 In.*
Exhibition: Smithsonian Institution Traveling Exhi-
bition Service (New York, Cooper Union Mu-
seum, Munich, Amerika Haus, Rouen, Musée
des Beaux-Arts [with catalogue in French], and
London, London Tea Centre), 1954, *An Exhibi-
tion of American Drawings,* no. 89.
Bibliography: *The Laura P. Hall Memorial Collec-
tion of Prints and Drawings,* Princeton, Depart-
ment of Art and Archaeology, Princeton Uni-
versity, 1947, no. 64 (listed).
Laura P. Hall Memorial Collection, bequeathed by
Prof. Clifton R. Hall (46-310)

This study is for one of Neagle's many portraits. He
has concentrated on catching the likenesses of the
children, knowing he can fill in later on the canvas
the lower parts of their anatomy.

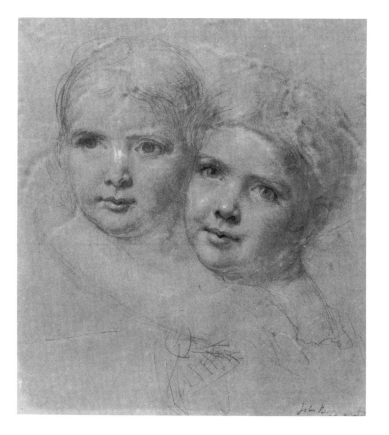

WILLIAM PAGE

Albany, N.Y. 1811–1885 Tottenville, Staten Island, N.Y.

111 *Self-Portrait*

Charcoal and white chalk over pencil on tan paper.
 0.455 x 0.368 m.
Inscription: lower left by the artist, *WP / 1843*.
Provenance: estate of Albert Rosenthal, Phila-
 delphia; purchased by F. Kleinberger Galleries,
 New York, 1945; purchased by the donor.
Bibliography: Joshua C. Taylor, *William Page: The
 American Titian*, Chicago, University of Chicago

Press, 1957, pp. 56–57, no. 81 and fig. 17.
Gift of Frank Jewett Mather, Jr. (49-4)

Page's painted *Self-Portrait as a Roman Senator*
was exhibited at the National Academy in the same
year that this drawing was executed, 1834. The
drawing may well be related to this lost painting.
Two other portraits, also exhibited in 1834, are sim-
ilar to this drawing in composition and the position
of the sitter.

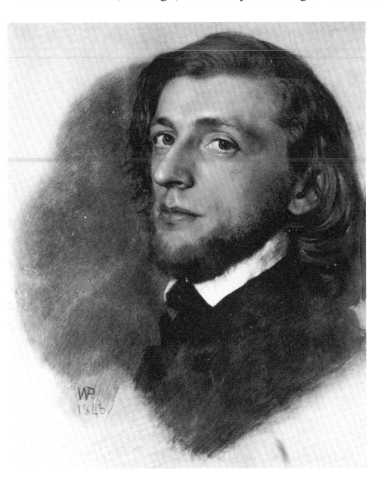

WILLIAM McGREGOR PAXTON

Baltimore 1869–1941 Newton, Mass.

112 *Seated Woman*

Black crayon, white highlights, on greenish gray
 paper. 0.254 x 0.203 m.
Inscription: lower right by the artist, *Paxton*.
Gift of Frank Jewett Mather, Jr. (50-39)
This drawing, made between 1910 and 1920, is char-
acteristic of a number of works Paxton executed
during the time he was teaching at the Museum
School, Museum of Fine Arts, Boston.

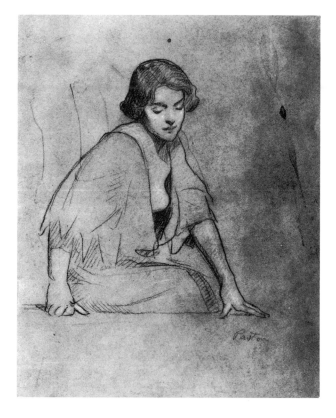

WILLIAM RIMMER

Liverpool, England 1816–1879 South Milford, Mass.

113 *The Shepherd*

Brown and reddish brown pastel over pencil on brown-washed tan paper. 0.355 x 0.54 m.

Provenance: Miss Susan Minns, Boston (label on back of former frame); lent by her to Museum of Fine Arts, Boston, 1916 (loan no. 153.16); Giovanni Castano, Boston, 1950; purchased by the donor.

Gift of Frank Jewett Mather, Jr. (50-40)

Jeffrey Weidman, who is doing research for his Ph.D. dissertation on Rimmer for Indiana University, believes this is an early work. He has called our attention to Rimmer's variant treatments of the same subject in another drawing and in an oil painting (1877), both at the Francis A. Countway Library of Medicine, Boston. Rimmer's knowledge of human anatomy, acquired in studying medicine (which he practiced intermittently), and his sculptor's sense of mass are demonstrated here.

ELLEN ROBBINS

Boston? 1828–1905 Boston?

114 *Marsh Marigolds*

Watercolor. 0.378 x 0.398 m. (bottom cut irregularly).

Inscription: lower right in brush and black wash by the artist, *Ellen Robbins / 1891.*

Gift of Stuart P. Feld, Class of 1957, and Mrs. Feld (70-136)

This is the work of a popular Boston flower painter who exhibited in many watercolor exhibitions. Her pictures were published by Louis Prang in several of his famous chromolithographic reproductions.

THEODORE ROBINSON

Irasburg, Vt. 1852–1896 New York City

115 *Under Green Apple Boughs*

Watercolor over pencil. 0.166 x 0.356 m.
Inscription: upper right in black ink by the artist, *Theo. Robinson / 1880.*
Exhibition: New York, American Water-Color Society, 14th annual exhibition, February 1881, *Illustrated Catalogue,* no. 531 (illus.).
Bibliography: John I. H. Baur, *Theodore Robinson: 1852–1896,* Brooklyn, N.Y., Brooklyn Museum, 1946, no. 326 (listed).
Gift of Frank Jewett Mather, Jr. (48-1813)

Winslow Homer's *Eastern Point Light* (no. 38, above) was in the same American Water-Color Society exhibition. After his first European studies, his finances depleted, Robinson returned to his family's home in Evansville, Wisconsin, in 1880. This watercolor probably was painted there. The artist frequently based his works on carefully posed photographs; perhaps the stiffness of pose is a result of this procedure. Robinson was to paint many variations on the theme of handsome women in outdoor settings.

ALBERT PINKHAM RYDER

New Bedford, Mass. 1847–1917 Elmhurst, Long Island, N.Y.

116 *Windmill*

Pencil; on a sketchbook leaf. 0.11 x 0.175 m.

Inscription: by the artist, *Green Trees / Old Gold / O. G. / Silver.*

Provenance: the artist's family; Mrs. Norma A. Lindsay (a relative?); Babcock Galleries, New York; purchased by the donor.

Bibliography: William I. Homer, "A Group of Paintings and Drawings by Ryder," *Record of The Art Museum, Princeton University,* 18, no. 1, 1959, pp. 31–32 and fig. 7.

Gift of Alastair B. Martin, Class of 1938 (57-114)

117 *Detail of Windmill*

Pencil; on a sketchbook leaf. 0.11 x 0.175 m.

Inscription: by the artist, *3d & 4th / cleet / Green white outside / above / Shadows same as strips in begin*[?].

Provenance: the artist's family; Mrs. Norma A. Lindsay (a relative?); Babcock Galleries, New York; purchased by the donor.

Bibliography: Homer, "A Group of Paintings and Drawings by Ryder," pp. 31–32 and fig. 8.

Gift of Alastair B. Martin, Class of 1938 (57-115)

The two drawings above are both on leaves from the same sketchbook. The style of the windmill is local to the Cape Cod area, where Ryder grew up. These early sketches from nature possibly date from before the artist moved to New York in 1870. A painting by Ryder of circa 1880, entitled *The Windmill* (Guennol Collection), may have some relation to these drawings. These rare sketches demonstrate an attention to detail not evidenced in Ryder's oils, where detail is obscured by a heavy build-up of paint and by bold masses of color and light and dark.

118 *The Story of the Cross*

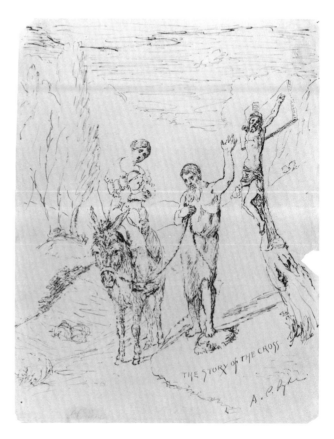

Pen and bluish black ink. 0.193 x 0.145 m.

Inscriptions: lower right by the artist, title as given / *A. P. Ryder;* lower left in pencil,—*4 in* —; verso, in pencil, *Original owned by* / *Col. C. S. Wood* / [. . .] / *Ferargil* / *Return to C. de Kay* / *103 E.15.*

Provenance: Charles de Kay (friend and first biographer of the artist); Ferargil Galleries, New York.

Exhibition: Washington, D.C., Corcoran Gallery of Art, 8 April–12 May 1961, *Albert Pinkham Ryder,* no. 50.

Gift of Frank Jewett Mather, Jr. (48-1789)

The title, dimensions, calligraphic quality, and size indication inscribed at the bottom all suggest that this was an intermediate drawing between Ryder's painting of the same subject and a print, probably never realized. We know little of Ryder's working methods, but all evidence indicates that any preliminary sketches would have been done directly on the canvas and that the areas of paint, often as important to the paintings as their actual subjects, were built up in an improvised manner. At least three painted versions of this subject exist. The chronology of Ryder's work is difficult because of his habit of working on his paintings over a period of years; Lloyd Goodrich believes this subject was "begun several years before 1890."

JOHN SINGER SARGENT

Florence, Italy 1856–1925 London

119 *Portrait of Emile Auguste Carolus-Duran*

Pen and brown ink, white ink additions. 0.317 x 0.26 m.

Inscriptions: upper right by the artist, *John S. Sargent;* lower margin at left by the artist, *à mon ami M. Dumas / John S. Sargent.*

Provenance: [Alexandre?] Dumas; possibly Dr. Daniel A. Heubsch.

Gift of Frank Jewett Mather, Jr. (52-84)

In this drawing, which can be dated 1879, the young

Sargent is portraying the master, in whose atelier he studied from 1874 to 1878. Sargent had difficulty representing this man, for whom he had great respect, and he was self-conscious about his style. Both sitter and artist seem aware that the master is paying his prize student a compliment by sitting for him. These qualities are preserved in the painting for which this is a study, now in the Sterling and Francine Clark Art Institute, Williamstown, Mass. David McKibbin (in *Sargent's Boston,* Boston, Museum of Fine Arts, 1956, p. 93) lists two oil studies and an unlocated drawing, ex-coll. Dr. Daniel A. Heubsch, for this painting. The latter may be the present study.

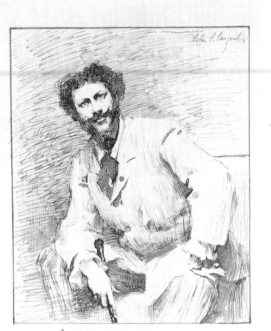

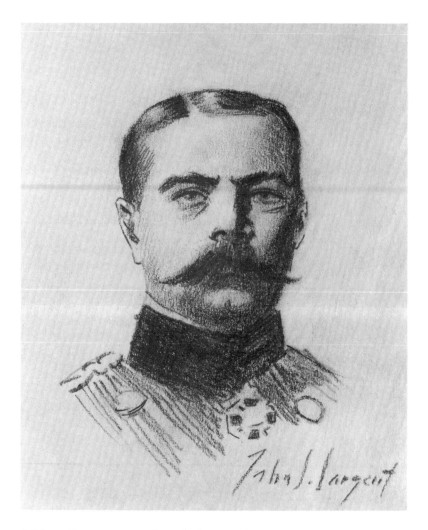

120 *Portrait of Lord Kitchener*

Charcoal over pencil on gray paper. 0.268 x 0.195 m. (irregular).

Inscription: lower right by the artist, *John S. Sargent*.

Provenance: John Davis Hatch; Ferargil Galleries, New York (note on former mat).

Gift of Frank Jewett Mather, Jr. (48-1815)

The uniform that the subject is wearing suggests that this portrait study of Lord Horatio Herbert Kitchener (1850–1916), dates around 1903, when the sitter was commander-in-chief of military forces in India. By this time Sargent was an extremely popular and sought-after portraitist. He worked from charcoal sketches and usually required several sittings. Kitchener is quoted as saying that there were two things he hated—public dinners and being photographed (P. Magnus, *Kitchener: Portrait of an Imperialist*, London, J. Murray, 1958, p. 68). No finished painting by Sargent of Kitchener is known; perhaps Kitchener's sentiment carried over to sitting for portraits, or his time in London might have been too short to allow the artist to capture his likeness satisfactorily.

FRANCIS HOPKINSON SMITH

Baltimore 1838–1915 New York City

121 *"For Men May Come and Men May Go, But I Go on Forever"*

Charcoal, brown and black pastel, heightened with white tempera, on brown paper. 0.695 x 1.25 m.
Inscription: lower left in charcoal by the artist, *F. Hopkinson Smith.*
Exhibition: New York, American Water-Color Society, 1875, *Catalogue of Water-Color Paintings at the April Meeting of the Union League Club* (8th annual exhibition of the Society?), no. 79.
Gift of Stuart P. Feld, Class of 1957, and Mrs. Feld (74-29)

This drawing illustrates Tennyson's poem "The Brook." With drawings such as this, and paintings and lithographs, Smith took advantage of a post-Civil War affluence and a desire for culture on the part of middle-class businessmen in New York, and catered to their tastes. Several of his paintings and a set of lighographs are landscapes based on literary works.

THOMAS SULLY

Horncastle, Lincolnshire, England 1783–1872 Philadelphia

122 *Sketches of Women*
Verso: *Seated Woman Reading in a Landscape; Two Seated Women*

Pen and black ink over pencil and red chalk (depending on area) on grayish tan paper. Verso: red chalk. 0.224 x 0.292 m.

Inscriptions: by the artist, *from King / King / B Sienna / Red / Gn /* [. . .]; verso, *King.*

Gift of Frank Jewett Mather, Jr. (44-521)

The Metropolitan Museum of Art, New York, has a sketchbook by Sully, dated 1810[?]–1819, with pages of similar size and paper to this sheet. It has been suggested that the "King" referred to in the inscription is Charles Bird King (1785–1862), who shared a room with Sully in London in 1809, when they were both studying with Benjamin West. Later King and Sully were friends in Philadelphia, where they both settled. Sully filled many similar sketchbooks throughout his career, and often copied other artists' works. The pose of the central figure with guitar is characteristic of those in his portraits.

ABBOTT HANDERSON THAYER

Boston 1849–1921 Dublin, N.H.

123 *Girl Arranging Her Hair*

Verso: *Sketch of Same Subject within Drawn Border; Two Partial Sketches*

Soft pencil. Watermark: [*Whatm*]*an*[?] *1906*. Verso has harder pencil additions. 0.379 x 0.334 m.

Inscriptions: recto and verso, lower left by the artist, *A H.T.*

Provenance: the artist's estate; Giovanni Castano, Boston (Fogg Art Museum loan sticker on former frame).

Bibliography: Gerald H. Thayer, "Nine Pencil Drawings by Abbott H. Thayer: Notes," *International Studio,* 74, January 1922, p. ccx and illus.

Gift of Frank Jewett Mather, Jr. (51-130)

The sitter for this drawing is Alma E. Wollerman, later Mrs. Gerald H. Thayer. Alma entered the household as a model shortly after the marriage of Thayer's first daughter, Mary, in 1906, and was his chief subject until she married the artist's son in 1911. His son describes the drawing as "a seven-minute sketch . . . perhaps the most interesting of a number of pencil studies of the same theme." At least three nearly identical versions of the subject exist in oils. It was the artist's practice to engage his assistants in making copies of his paintings. He would himself work on these copies intermittently, often making changes many years later. He apparently had no scruples about signing and dating these and calling them his own; in fact, there seems to have been no distinction between "original" and "copy" in his mind. Thus we find a version of this subject dated 1906 (the "original"?) in the New Britain Museum of Art; there is a version in the Canajoharie Library and Art Gallery, Canajoharie, N.Y.; and the National Collection of Fine Arts, Washington, D.C., has one dated 1919. The date of the present drawing is surely 1906.

WILLIAM GUY WALL

Dublin, Ireland 1792–after 1864 Ireland

124 *Riverside Landscape with Ruins and Tree Stump*

Pencil. 0.188 x 0.172 m.
Inscription: lower right by the artist, *W G Wall N. Academy.*

Exhibition: Brooklyn, N.Y., Brooklyn Museum, 25 November 1969–22 February 1970, *Drawings of the Hudson River School 1825–1875* (by Jo Miller), no. 92 (illus.).
Gift of Frank Jewett Mather, Jr. (44-217)

JULIAN ALDEN WEIR

West Point, N.Y. 1852–1919 New York City

125 *Two Women Sewing*

Watercolor over pencil. 0.253 x 0.35 m.
Inscription: lower right by the artist, *Weir*.
Gift of Frank Jewett Mather, Jr. (44-549)

This watercolor probably dates from circa 1885,
when the artist painted several such subjects in this
medium.

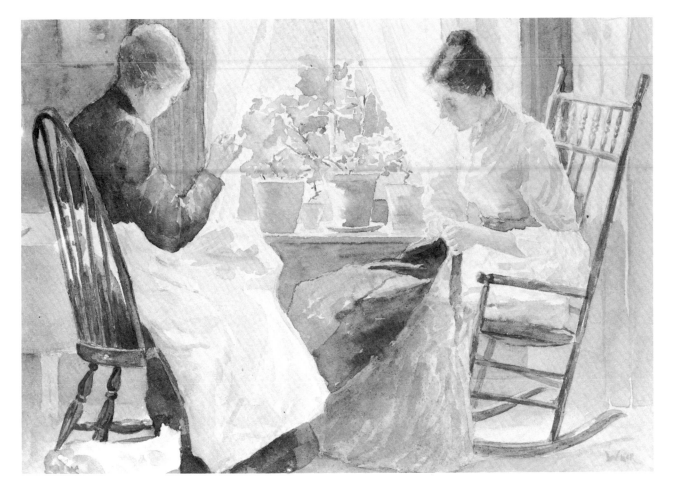

126 *Moonrise*

Pastels over pencil. Watermark: *E D & Cie* in ornamental border. 0.3 x 0.453 m. Page from *Evening Telegram,* 22 October 1907, behind picture in former frame.

Inscription: lower left in pencil by the artist, *J. Alden Weir.*

Provenance: Montross Gallery, New York (label on back of former frame); Frank Jewett Mather, Jr.; his estate.

Gift of Mrs. Frank Jewett Mather, Jr. (57-119)

A paper label on the back of the former frame gives the title as *Landscape in Moonlight.* The old piece of newspaper accurately dates the work to circa 1907. The scene is probably near the Weir home in Branchville, Conn., where the artist used to take long walks, sketching along the way.

ROBERT WALTER WEIR

New York City 1803–1889 New York City

127 *Falstaff and Mistress Ford*

Pen and brown ink, with brown, white, and gray
wash, over pencil on bright yellow paper. 0.206 x
0.135 m.
Inscription: lower left in pen and ink by the artist,
R. W. Weir.
Gift of Frank Jewett Mather, Jr. (49-13)

This is a scene from Shakespeare's *The Merry
Wives of Windsor* (act 4, scene 2). A painting corre-
sponding to this scene has not been located, but
there exist two oils by Weir illustrating other scenes
from the same comedy, dated 1930 and 1931. It can
be assumed that this drawing is from the same pe-
riod, shortly before the artist was appointed as in-
structor and professor of drawing at West Point Mili-
tary Academy, a position he held for over forty
years. Robert Walter is father of the preceding
artist.

BENJAMIN WEST

near Springfield (now Swarthmore), Pa. 1738–1820 London

128 *Hope*

Red chalk. Watermark: *J. Bigg.* 0.378 x 0.315 m.
Gift of Stephen Spector (66-21)

Two other drawings by West of the figure of Hope, both pen and ink and dated 1783, are in the Pennsylvania Historical Society, Philadelphia, and in the Art Gallery of Ontario, Toronto. Another drawing of Hope (1769?) is in the Maritime Museum, Greenwich, England. The latter is related to sculptures by John Bacon, perhaps after West, in the vestibule of the Chapel of Saint Peter and Saint Paul, Greenwich

Hospital. Princeton's elegant drawing probably dates before 1780.

129 *Apotheosis of Three Children*
Verso: *Sketch for Same Subject*

Black and plum-colored chalk. Watermarks: *T. French* and *Pro Patria* with "Garden of Holland" (rampant lion and maid of Dort, letter *F* between, in enclosure) (similar to Churchill 144: English, 1781). 0.329 x 0.382 m.
Inscription: verso, in pencil, *West.*
Provenance: Thomas Parsons & Sons, London; purchased by Dan Fellows Platt, 1928.
Dan Fellows Platt Collection (48-36)

The subject of this drawing, which is a common one in West's oeuvre, was identified by Helmut von Erffa. (Because the two outer children seem protective of the center one and the smallest one is pointing to him, and because the oldest child, in the verso drawing particularly, appears to be a young woman, this writer has entertained the notion that the subject might be a Madonna and Child and Saint John protected by an angel.) The looser drawing style indicates a date in the 1780s.

130 *Angel of the Annunciation*

Pencil or black chalk, pen and brown ink, brown wash, thick white oil(?) paint, on blue paper. 0.272 x 0.199 m.
Provenance: Victor Winthrop Newman, New York (Lugt 2540, lower right); his sale, Anderson Galleries, New York, 2 February 1920, no. 103; purchased by the donor.
Exhibition: Princeton 1943, no. 3 (as *An Angel*).
Gift of Dickson Q. Brown, Class of 1895 (43–63)

129

Just as the above drawing demonstrates a common protective or beneficent angel type in West's oeuvre, a male figure similar to the one here seemingly is portrayed whenever the artist wanted to represent an avenging or assertive angel. Mr. von Erffa believes this drawing is specifically related to *The Angel of the Annunciation* that West created for the organ arch of Saint Marylebone Parish Church, London. The work, which has been described as a painted "transparency" on canvas, was installed in 1817 and removed only nine years later, in 1826. After being kept in storage for fifteen years, it was sold at auction in April 1840, according to a contemporary description (Benjamin Robert Haydon, *The Autobiography and Memoirs,* ed. by T. Taylor, New York, Harcourt, Brace, 1926, vol. 2, p. 677 n.1) to a John Wilson, who contemplated selling it in America. Its present location is unknown. The Marylebone painting in turn was related to a stained-glass window that West designed in 1791 for Windsor Castle, Saint Georges' Chapel. In the annual exhibition of the Royal Academy, London, for 1790, there was an *Angel of the Annunciation for Windsor* by West, exhibited as no. 111.

APPENDIX

Sketchbooks by Thomas Cole and Homer Dodge Martin

The following two sketchbooks will not be fully described or illustrated here because they are the subject of excellent articles by Louis Hawes and Frank Jewett Mather, Jr., respectively, in the *Record of The Art Museum, Princeton University*. We felt that it would be useful, however, to record systematically the contents of the sketchbooks and the important inscriptions.

Thomas Cole Sketchbook 1839–1844

Marbled paper boards, brown leather spine and corners, spine ruled with gold. On torn paper label attached to front cover, in pen and black ink, *Sketchbook=1839–18*[torn away] / *THOMAS COLE, ARTIST —* / *Theodore A. Cole.* 0.291 x 0.438 m. (each leaf 0.284 x 0.43 m.).

Provenance: Mrs. Florence Cole Vincent (the artist's granddaughter); purchased by the donor at Cole's Catskill studio.

Exhibition: Hartford, Wadsworth Atheneum, and New York, Whitney Museum of American Art, 1948–1949, *Thomas Cole 1801–1848: One Hundred Years Later*, no. 59.

Bibliography: Louis Hawes, "A Sketchbook by Thomas Cole," *Record of The Art Museum, Princeton University*, 15, no. 1, 1956, pp. 2–23 (illus.).

Gift of Frank Jewett Mather, Jr. (40–78)

The following folios are in pencil, unless otherwise indicated. The numerous descriptive notes Cole scattered on these sketches have not been transcribed here except where they indicate geographi-

cal locations. The particularly fine notes on folios 11v and 12 are included here as a sample, however: *buildings / surf / yellowish sand / white beach / sand / Hemlock woods / scattered buildings / pretty clean and clear / grassy / soft gray warm / beach of golden colored sand with dark sand scattered in it / very dark brownish / very brown / sand under water / meadows / spruce / dark green bushes /* [at the side, Cole writes:] *This is a very grand scene — The craggy Mountains, the dark pond of dark brown water — The golden sea sand of the beach & the light green sea with its surf altogether with the woods of varied colors — make a magnificent effect such as is seldom seen combined in one scene.*

Inside front cover: Three romantic landscape sketches. *Knight fording a stream Castle on a cliff near / Ruined City / Thomas Cole 1839 / [. . .].*

1 Missing.

2 Copy after Flaxman's Aeschylus illustration, *Orestes Imploring Apollo to Deliver the Furies* (Orestes represented as an artist presenting a book of sketches). Miscellaneous notations.

2v Romantic landscape sketch. Studies of head and foot of a child.

3 Faint sketch for *The Architect's Dream*, 1840 (lion instead of architect on pedestal in foreground).

3v *Alton Bay / Winnipissagee* [Winnipesaukee]. Miscellaneous notations. Sketch of hemlock plant.

4 *Notch in the White Mountains from above / with the Notch House* [Crawford Notch]. Miscellaneous notations. Painting, *The Notch in the White Mountains,* 1839 (National Gallery of Art, Washington, D.C.), is very similar (slight changes in foreground, composition, and introduction of mounted rider). This drawing is cited in Howard

S. Merritt, *Thomas Cole*, Rochester, N.Y., University of Rochester, Memorial Art Gallery, 1969, under entry for painting, no. 39.

4v Slight sketch of building flanked by two towers.

5 Trees on a slope.

5v–6 River landscape (Catskill Creek from Jefferson Heights). Rough sketch of same to left. *Sept 9th 1842* / miscellaneous notations. Painting, *River in the Mountains,* 1843, of the same scene is in the Museum of Fine Arts, Boston, Karolik Collection.

6v *Confluence of Catskill & Kaaterskill / August 5th 1844* / miscellaneous notations.

7 Tree and rocks.

7v Three scenes and detail of buoy. *Penobscot Bay / Brigadiers Island / The Bluff / Long Island / Penobscot Bay.*

8 Cove, probably on Penobscot Bay.

8v–9 *Old Fort [George] at Castine.* Small sketch of standing man reading a book, inscribed, *Mr. Pratt.* Miscellaneous notations, including, *Brigadiers' Island / Built in 1779 or about.*

9v *Old Fort at Castine / [. . .].*

10 *Scene in Mt. Desert / looking South / [. . .].*

10v *View from Mt. Desert / looking inland / westerly / [. . .].*

11 *From Mt. Desert looking South by east / Fresh Water Pond* [probably Jordan Pond] / [. . .].

11v–12 *Mt. Desert / Sand Beach Mountain, Mt. Desert Island* [now Great Head?] [. . .].

12v–13 *Hulls Cove. Mt. Desert / Bar Island* [. . .].

13v (left half) *Mills, Ellsworth Maine / [. . .].*

13v–14 *Islands in Frenchmans' Bay from Mt. Desert.* Individual islands are numbered; key at upper right identifies them and gives descriptive notes. Painting, *View across Frenchman's Bay, from Mount Desert Island, Maine, after a Squall,* 1845 (Cincinnati Art Museum) is very similar.

14v *View of Mt. Desert / from Trenton on the Mainland / Jordan River / called Big Day Mt. / [. . .].*

15 *Pond between Ellsworth & Bucksport / Maine / [. . .].*

15v–16 *Mt. Desert Island in the distance seen from the Main Land / Newport Mt. / Big Day Mt. / Buck Hill / [. . .].* Details of rocks lower right.

16v–17 Catskill Mountain House from North Mountain. Miscellaneous notations. The painting *A View of the Two Lakes and Mountain House, Catskill Mountains, Morning,* 1844 (Brooklyn Museum) is very similar. See discussion above under related drawing, no. 8.

17v Tree. Miscellaneous notations.

18 Rough sketch of a rocky ledge (probably ledges on North Mountain). Slight sketch labeled *Mountain House.* Miscellaneous notations.

18v–20 Blank.

20v Mill(?) building on river with two dams. Childlike drawing of sun, upper left. Miscelleanous notations.

21–22 Missing.

23 Two trees.

23v Mount Aetna. Miscellaneous notations. Divided by diagonal pencil lines.

24 Rough landscape sketch.

24v Line drawn with straight edge.

25 Profile bust of praying figure. Hawes indicates a relation to one of the figures in Flaxman's illustrations to Dante's *Purgatorio.* The similarity of pose with the man in the boat in Cole's *The Voyage of Life: Old Age,* 1840 (Munson-Williams-Proctor Institute, Utica, N.Y.), should also be noted.

25v Studies of a male figure with clasped hands. Probably for *Manhood* in same series of paintings, also in Utica.

26 *Inlet of Sea, Penobscot Bay*.

26v Three figure studies for *The Voyage of Life* series: a youth; a study of his left hand on tiller (for *Youth*); and flying angel with hourglass (for *Childhood* or *Manhood*).

Inside back cover: Diagram of chromatography and long inscription copied by Cole from George Field's *Chromatography*. Pen and brown ink. Slight pencil sketch of a romantic landscape with tower. Fully discussed and illustrated in William I. Homer, "Thomas Cole and Field's 'Chromatography,' " *Record of The Art Museum, Princeton University*, 19, 1960, pp. 26–30.

This sketchbook spans a period of five years, perhaps the most productive of Thomas Cole's short life. There are early romantic studies from 1839, followed by at least two from a trip to New Hampshire in the same year. Back at his Catskill, New York, studio, Cole studied scenes on the Catskill Creek in 1842 and 1844, the only two dated leaves. In the latter year he went to Maine, where he made the studies in the vicinity of Penobscot Bay and Mount Desert Island that comprise the majority of scenes in the sketchbook. Back home he studied the Catskill Mountain House, still probably in 1844. The study of Mount Aetna is the result of Cole's second European trip, 1841–42. Mr. Hawes speculates in his *Record* article that this drawing was probably executed in the artist's Catskill studio after his return from Europe. Hawes is correct in stating that there are no important drawings in this sketchbook for the years 1839 and 1840, when Cole was occupied with his *The Voyage of Life* series; however, the few slight figure sketches (folios 25, 25v, and 26v) are certainly related to this cycle. It is interesting to contrast the artist's attention to details, confident lines, and close observation of nature in his landscape sketches with the clumsiness, pencil-pushing (Hawes' description) quality and improvised nature of his figure studies, which may even be borrowed from another artist. As Hawes has indicated, four important landscape paintings resulted directly from sketches in this book, and two others, *Mt. Aetna* and *The Architect's Dream*, certainly are related.

Homer Dodge Martin Sketchbook 1875–1876

Green cloth binding, green leather spine, gray paper leaves. 0.13 x 0.207 m. (each leaf 0.124 x 0.201 m.).

Provenance: Ralph Martin (the artist's son); Gertrude Hall Brownell (Mrs. W. C. Brownell); Frank Jewett Mather, Jr.

Bibliography: Frank Jewett Mather, Jr., "A Sketchbook of 1875 and 1876 by Homer D. Martin," *Record of The Art Museum, Princeton University*, 4, no. 1, 1945, pp. 5–8 (illus.).

Presented by Frank Jewett Mather, Jr., as the gift of Mrs. William Crary Brownell and himself (43-101)

The following folios are in soft pencil, except where noted.

Inside front cover: *Farmingham. Kent / Bromley. Kent — Victoria Station / Maidenhead — Paddington Station / Cookham just above* [all names of train stops].

1 In pen and ink, *To Frank Jewett Mather / with kindest regards of / Gertrude Hall Brownell / who received this sketch book / from Ralph Martin / son of Homer Dodge Martin / May 25, 1942.* On laid-in handwritten calling card: recto,

in pen and ink, *Ralph Martin / 145 Kinney St. / Ocean Park / Calif.;* verso, in pencil, *This, My Dear Mrs. Brownell / will, I believe, prove to be interesting and informative / to you, Anyhow I hope so / RM.*

2 Portrait of a man.

2v–3 Boating scene. *Thames / near Marlow Aug 14 76.*

3v–4 House on a river. *Aug. 14. 76.*

5 Figure fishing, round building. *Aug 14 76.*

6 House and two figures. *Aug 14. 76.*

7 Buildings. *Medmenham / Aug. 13. 76.*

7v–8 Windsor Castle. *Windsor / July 30. / 76.* Painting, 1878, of same view is illustrated in Dana H. Carroll, *Fifty-Eight Paintings by Homer D. Martin,* New York, 1913, no. 22.

9 Three cranes.

10 Bear.

11 Trees and two figures. *St. Cloud 25 June 76.*

12 Buildings on shore. *Selkirk. Oct 8 / 75.* White ink additions.

12v–13 Forest scene. *Sep. 21 75.*

14 Mountains.

15 Bare trees.

16 *Ferguson's / Shanty / Lewey Lake Sep. 16 75.*

17 Forest and brook. *Sep 13. / 75 / 13th Brook.*

18 Seated woman.

18v–19 Lake scene with mountains and trees. *[?] / Aug 31 / 75.*

20 Two men fishing. *(This is R.M.[Ralph Martin?] & his brother) / H.D.M. / 1875.*

21 Studies of a fisherman casting.

The time sequence is reversed because the artist began at the back of the sketchbook and worked forward. The artist's wife mentions (in *Homer Martin: A Reminiscence,* New York, 1904, pp. 40–41) that W. C. Brownell asked Mrs. Martin if he could purchase a particular sketchbook of Martin's European stay if it were ever put up for sale. The sketchbook was lost when the artist was packing in 1893 to go to Saint Paul, Minnesota. Perhaps his son, Ralph Martin, gave this sketchbook to Mrs. Brownell as a substitute. In the sketchbook, we can follow the artist from this country (Lewey Lake in the Adirondacks is the only identified place) to Selkirk, St. Cloud, and then along the Thames River in England. Even on his travels in England and France he appears not to seek famous buildings or spectacular sights, but, rather, the same kind of picturesque and quiet landscapes that he recognized at home.